The Infamous
BIRMINGHAM
AXE MURDERS

The Infamous
BIRMINGHAM
AXE MURDERS

Prohibition Gangsters & Vigilante Justice

JEREMY W. GRAY

THE
History
PRESS

Published by The History Press
Charleston, SC
www.historypress.net

First published 2018

Manufactured in the United States

ISBN 9781625858979

Library of Congress Control Number: 2017960113

To Willa and Joe
You are the sun and the moon, my heart and my soul, the highlights of my life.
Always remember: the real axe murderers were never caught.
I think they live in the woods by our house.

For a ghost story to be interesting, it had to have happened to interesting people.
—Kathryn Tucker Windham

The Lord knew I lived in a hard town, so he gave me a hard head.
—The Reverend Fred Shuttlesworth

I'm a lover of the Southland,
Living down in Alabam'—
In the fairest of her counties,
In her favorite Birmingham,
Garden spot of dear old Dixie,
She hath made me what I am,
For Birmingham's my home.
—Sung to the tune of "The Battle Hymn of the Republic"

CONTENTS

1

"THE MOST BRUTAL AND HEARTLESS MURDERS"

1919–1921

December 24, 1919, was a long night for Birmingham detectives, and by Christmas morning, they had little to show for their work. As Birmingham celebrated Christ's birth, welcomed the soldiers returning from the Great War and anticipated its fiftieth birthday, the city unknowingly entered one of its darkest chapters, even as its brightest days seemed to lie ahead.

On the morning of Christmas Eve, well-known businessman John H. Belser descended from the small room where he lived alone to open the general store he had operated for twenty-five years at 1801 Fifth Avenue North, not knowing it would be the final time he opened his shop. "To some, Belser was known as a miser and many said he had a large amount of money," the *Birmingham News* declared atop a hastily redesigned front page that afternoon.

H.P. Parrish, manager of a nearby coal yard, went to the store around 7:00 a.m. to buy cigarettes. Parrish found Belser bound and gagged in a pool of blood, his cash register emptied of $600. Belser died without regaining consciousness, around 9:30 a.m. He was either fifty-six or sixty-five, depending on which press account you prefer. The *Birmingham Age-Herald* reported Belser owned property valued at $150,000—$2.2 million by today's standards. In some accounts, he had a millionaire brother who would soon leave his Los Angeles home to plan Belser's funeral. In others, he was a Syrian immigrant who left an unclaimed fortune.

Although Belser was beaten with a shovel, his death was years later listed by police as the first in a bizarre, bloody and strangely disjointed series of attacks on immigrant merchants and interracial couples that left twenty people dead and twenty-one others injured over the course of four terror-filled years.

Speaking to reporters early on Christmas Day, detectives acknowledged they had little to go on. It appeared Belser was fetching something from a cabinet, at the request of a customer, and then bludgeoned from behind. Detectives would become very familiar with this modus operandi over the next few years, as they would see it again and again as small shops were turned into crime scenes. Though violence was nothing new to the rough-and-tumble city, the daytime robbery and vicious murder of a wealthy merchant shocked Birmingham. Yet with so few clues to go on, the investigation made little headway, and the murder soon vanished from memory for over a year.

When the perpetrators next struck, eighteen months later, they would spark panic that would drive police and politicians to turn to Ouija boards, truth serums and the Ku Klux Klan until someone was made to answer for the crimes. Merchants would take up arms, firing wildly at anyone they deemed suspicious, and copycat killers emerged from shadows. Belser's murder remained a mystery. Why the absence of axe murders between Belser's case and the next? Was the killer locked away or on the run? Was Belser's death truly related to the axe cases, or were police merely trying to pin a years-old unsolved homicide on the mysterious axe men?

Or was Belser's murderer the axeman of New Orleans?

"At Will I Could Slay Thousands"

Two months before Belser's murder, grocer Mike Pepitone died in New Orleans' Charity Hospital. His skull had been crushed as he laid in bed. Pepitone's October 27, 1919 murder marked an end of an axe-murder spree that killed or badly injured a dozen people, mostly Italian merchants, in seventeen months. Had the killer taken the train line that carries passengers from New Orleans through Birmingham to New York City? "If I wished, I could pay a visit to your city every night. At will I could slay thousands of your best citizens, for I am in close relationship with the Angel of Death," someone claiming to be the New Orleans axeman wrote in a March 1919 letter to the *Times-Picayune*. The ultimatum continued:

Now, to be exact, at 12:15 (earthly time) on next Tuesday night, I am going to pass over New Orleans. In my infinite mercy, I am going to make a little proposition to you people. Here it is:

I swear by all the devils in the nether regions that every person shall be spared in whose home a jazz band is in full swing at the time I have just mentioned. If everyone has a jazz band going, well, then, so much the better for you people. One thing is certain and that is that some of your people who do not jazz it on Tuesday night (if there be any) will get the axe.

Jazz was heard across the city that night and no axe murders reported.

As fear of axe attacks in New Orleans subsided in 1919, Birmingham had no idea the kind of bloodshed, and hysteria, the city would endure in the 1920s when its own axeman, with his own violent methods, returned to the Magic City.

"HE JUST WAITED TO DIE"

The peace enjoyed by Birmingham merchants ended on March 5, 1921, when C.C. Pipkins was attacked at his grocery store at 500 Walker Street in Birmingham's West End. Two men hit Pipkins in the head with an axe, but luckily for Pipkins, two customers approaching scared them away, police said. Pipkins was unable to describe his attackers, the *News* reported, but customers said they were two black men. Pipkins survived.

The first attacks that year received little attention, but before the end of 1921, with seven injured and four others murdered, the axe cases would create a city-wide panic. The spree continued on June 18, 1921, when J.J. Whittle was attacked at his shop on Eighth Avenue North and Weaver Street by two men who asked to buy an onion. When Whittle turned to get it, he was struck with an axe. The shopkeeper survived, but for whatever reason, he had little information to offer police about the men who robbed him.

A milkman arrived at 4510 Tenth Avenue North early on the morning of July 13, 1921—as he did each morning—to bring the daily shipment to the Baldones' family-run grocery. The Baldones were one of the many Italian families who put down roots in Birmingham and thrived for generations despite discrimination and crime. Charlie Baldone made the decision to leave Sicily, where he might earn six cents a day in sulfur mines, to come to

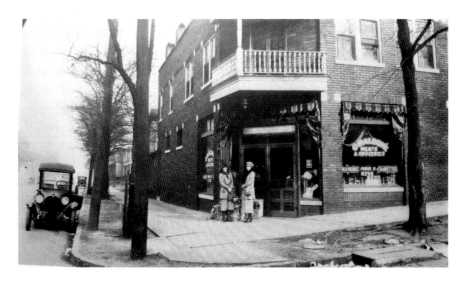

One of the Baldones' family stores, not the one where the 1921 attack occurred, is shown in this undated photo. A parking deck near the courthouse occupies the spot where this shop once stood. *From* The Italians: From Bisacquino to Birmingham.

America and its promise of one dollar per day in coal mines and steel mills. "They were told in Sicily that in America the streets were paved with gold. He got here and saw that was the first lie," said Butch Baldone, a direct descendant of Charlie Baldone. Still, Charlie worked and saved money to bring his wife over. "Whatever you found here, it was going to be a better life than over there," Butch asserted.

That morning, the milkman was surprised to find the store was still locked. "It wasn't supposed to be," said Baldone. "He looked in the window and saw the kids running around, all covered in blood."

The milkman alerted police, and they broke into the store, which Charlie apparently had locked after he was injured—possibly to keep the culprits from returning. "After my grandfather gets hit, he locks up and goes into the backroom to die," Baldone said. "He laid across his wife and just waited to die." His fourteen-year-old daughter, Virginia, had been struck in the head. Charlie's wife, Mary, had suffered a gruesome injury—one of the attackers had pounded a nail into her skull, something her grandson Butch Baldone suspects may have had symbolic significance to the assailants. "In organized crime, everything meant something, but I don't know what the nail might have meant," Baldone said. Other, younger children, including three-year-old Frank Baldone, were in the house at the time. Though left to run through puddles of blood, they were uninjured. All ultimately survived.

Baldone proposed that other family members had been bootleggers and the assaults might have been meant to send them a message, possibly that they should pay up if they wanted to keep up their illegal booze business.

"Robbery, vendetta, and vengeance of negro tenants were advanced as possible motives," the *Birmingham News* announced. Other news outlets reported that the Baldones refused to identify their attackers and the police believed the attack was the result of "a family vendetta." The couple's three-year-old son, Frank—Butch's father—told police he saw a black man strike his father, according to the *News*.

Born some twenty years after the attack, Butch Baldone is the owner of Baldone Tailoring Company, a downtown Birmingham institution since 1935. His greatest claim to fame is having paired Bear Bryant with his trademark houndstooth hat, and he keeps the walls lined with photos of the legendary coach. Butch Baldone believes the attack was the work of "The Black Hand," loosely banded rings of extortionists that plagued immigrant communities nationwide in the early twentieth century, and not the African Americans his family served in their store.

These Black Hand groups sought to extort money from immigrant merchants who might have no one to turn to for protection in the 1920s South, where they were viewed by the white establishment as sharing the lowest rungs of society with African Americans. The families were forced to make payments or see their loved ones hurt. "There was never a mafia

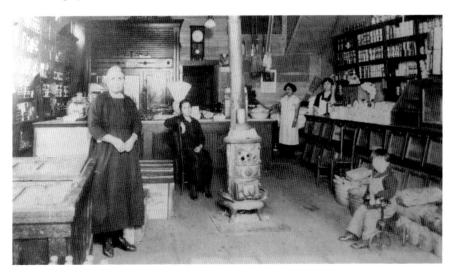

Unidentified members of the Baldone family in a family shop, undated photo. *From* The Italians: From Bisacquino to Birmingham.

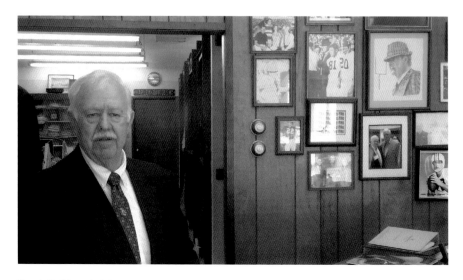

Butch Baldone in his downtown tailor shop. *Author photo.*

here in Birmingham like there was in New York, Chicago, Boston," Baldone affirmed. "There was a 'Black Hand.' They were basically bullies and thugs who feasted off their own people."

"The black people [Charlie Baldone] traded with, he would let them trade on credit. The white man wouldn't do that. And if they didn't have enough money, he would make sure they had something to eat," Butch Baldone said. His family had understood, to some degree at least, the discrimination African Americans faced in Birmingham. After the attack, doctors refused to treat the Baldones without payment up front, simply because they were immigrants.

"How do you live in a world like that? But that's the way it was," Baldone said. "And the police didn't do anything about it because it was just a bunch of Dagos. If you lived in Birmingham back then and you were Greek, Italian or Jewish, they called you Dago. They didn't know what they were talking about."

Baldone said family members and others in the Italian community took matters into their own hands. "About a month [after the attack], two men were found in Roberts Field each with a single gunshot to the back of the head." Roberts Field was Birmingham's primary airport from 1922 until 1935. In 1927, thousands gathered there to watch Charles Lindbergh land the *Spirit of St. Louis*. "That was the closest the mafia ever came to Birmingham." That bit of Baldone family history is perhaps

The sign outside of Baldone Tailors in downtown Birmingham. *Author photo.*

impossible to verify and, if true, the murders continued and fear spread across the city.

One month after the Baldones' assault, on August 17, 1921, Hyman Borsky opened his shop at 217 Eighteenth Street North. Mere minutes later, he "was found by a negro lying on a bench in the rear of the store with two wounds, apparently inflicted by a blunt instrument," the *News* reported. The customer ran for help. "He was bleeding profusely, one wound having cut a deep gash over his right eye and the other inflicting a serious cut under his right ear." The fifty-four-year-old was robbed of a gold watch, $40.00 in cash and two checks for $7.50, but he survived.

The next attack would come one month later. Sophie Zeidman was born in Russia, and by 1903, she and her husband, Sam, were living in Minneapolis. A year later, she gave birth to their son, Eugene, in St. Joseph, Missouri, per immigration forms provided by Zeidman's family. The family moved to Birmingham in 1910 and opened a shop on 1700 Ninth Avenue North. On the morning of September 6, 1921, Sophie Zeidman was working alone in the shop. Two black men allegedly entered the store and demanded her cash register, which contained $60, equivalent to about $750 today. When she refused, they bludgeoned her skull with a stick and fled.

Police said they were looking for two black men seen entering the store just before the robbery. A large crowd gathered at the scene, but police

Sophie Zeidman's immigration papers. *Provided by family.*

said it gave no answers. "The section is inhabited mostly by negroes," the *News* was sure to note. Zeidman, who was knocked unconscious, was taken to St. Vincent's Hospital and "apparently was suffering more from fright than from actual hurt" and would survive, the *Post* reported. Zeidman had every reason to be frightened: the next victim would not be so lucky.

PENNIES, PIGS' FEET AND A BLOOD-SOAKED APRON

G.T. Ary was the manager of Hill Grocery No. 25, at 1000 Twenty-Fourth Street North, part of a successful Birmingham-based chain that would come to share a sign with Piggly Wiggly before being purchased by Winn-Dixie in the 1960s. Ary, a husband and father of one, was attacked on Monday, November 28, 1921, and became the second life lost to Birmingham's elusive axeman. The next day's *Post* revealed that the cash register was robbed of thirty dollars. "The robber had apparently ordered some pigs feet and then, while his victim's back was turned, had struck him a terrific blow," the *Post* reported.

Two hours after the 7:00 p.m. attack, concerned when he did not return home from work, Ary's wife went to the store. Finding the door unlocked and the lights off, she notified police, perhaps too afraid to enter the store alone. At around 9:00 that night, two officers found Ary unconscious with a fractured skull. Still wearing his work apron, Ary was holding a bag containing a pig's foot in one hand and a pickled pig foot on a fork in his other hand. A few pennies were left behind in the register. He was rushed to Hillman Hospital but died around 2:00 a.m. two days later. "Officers worked upon the case for several hours last night and at latest report had found no one who was near the store at closing time nor did they secure any clew [*sic*] as to the robbers," the *Age-Herald* reported. Ary's murder showed the axeman would not limit his deadly work to the city's immigrant population. The murdered grocer was buried in his west Alabama hometown of Kennedy in Lamar County.

Hill Grocery offered a reward of $250, worth more than $3,000 today, but it would not stop the next atrocity from happening less than a month later.

"HIS MOTHER'S BLOOD SMEARED HIS FACE"

Thomas Price saw flames coming from the Collegeville store neighboring the owners' home and broke through a bedroom window to find the owners had been brutally attacked. Joseph Mantione, thirty-two, was in a puddle of blood on the floor of the three-room building. His wife, Susie Mantione, twenty, was in the couple's bed with her skull crushed. Price's wife pulled the Mantiones' unharmed ten-month-old son Pete from the fire. "A great splash of his mother's blood smeared the little fellow's face," the *Post* noted. By "merest accident," the *News* added, police later found a short-handled axe covered in blood and hair that had apparently been hidden under a stove before the building was set on fire. It was December 21, 1921, nearly two years after the Belser murder, and the Mantiones had been preparing to open their store at Thirty-Second Avenue North and Church Street. The Prices were one of several black families who rented property the couple owned near the store.

"Reports that a feud might be at the bottom of the crimes and that Mantione had some enemies who desired to put him out of the way were investigated," the *News* speculated the day of the murders. Price told the *Post* that someone had tried to break into the Mantione house a month earlier, but a dog's barking scared him off. "The fellow shot the dog as he was leaving," Price said. "Mr. Mantione told me if I saw anyone in my yard at any time, and they looked like they were up to anything, not to take chances. I believe Mr. Mantione was afraid of someone."

Detectives J.T. Moser and O.D. Brown, "two of the best criminal men in the city detective service," were assigned to the case, which was said to be among "the most brutal in city annals," the *News* announced. "This is one of the most brutal and heartless murders I have ever worked on and it must be a fiend who could hit a sleeping woman with a baby at her side with an axe," Detective Moser said.

Sometime around 4:00 a.m., Joseph Mantione was struck in the back of the head with an axe handle as he leaned over a basket of onions—his hat was found in the onion bin. The axe handle had been cut in half "to make a more handy club of the instrument," the *News* noted. "Then the assailant dragged the unconscious man from the store, where a pool of blood indicated the assault occurred, to the door leading from the store to the kitchen," the *Post* reported.

Susie Mantione was in bed with her son in a crib beside her. "He struck the defenseless woman a terrific blow on the back of the head, fracturing

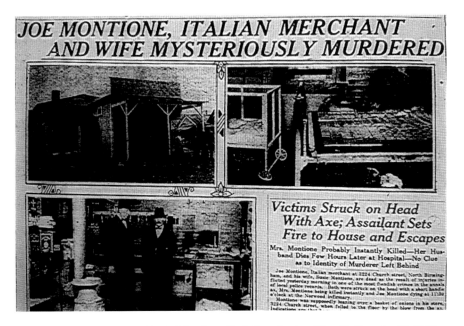

JOE MONTIONE, ITALIAN MERCHANT AND WIFE MYSTERIOUSLY MURDERED

Victims Struck on Head With Axe; Assailant Sets Fire to House and Escapes

Mrs. Montione Probably Instantly Killed—Her Husband Dies Few Hours Later at Hospital—No Clue as to Identity of Murderer Left Behind

Joe Montione, Italian merchant at 3224 Church street, North Birmingham, and his wife, Susie Montione, are dead as the result of injuries inflicted yesterday morning in one of the most fiendish crimes in the annals of local police records. Both were struck on the head with a short handle ax, Mrs. Montione being killed instantly and Joe Montione dying at 11:30 o'clock at the Norwood infirmary.

Montione was supposedly leaning over a basket of onions in his store, 3224 Church street, when felled to the floor by the blow from the ax. Indications are that ...

The shop where Joseph and Susie Mantione died. *From* the Age-Herald, *December 22, 1921.*

her skull," the *Post* continued. "Wielding the axe again the murderer struck her while she lay in bed. Mrs. Mantione was killed instantly," the *News* added. "After ransacking rooms for valuables, he poured kerosene over the bedclothing and set it afire." The fire was close to burning the baby's bed when the Prices rushed in. Neighbors, mostly black, doused the fire with buckets of water and a garden hose and sounded the fire alarm. Thomas Price carried Susie Mantione from the burning, blood-soaked bed, stumbling over Joseph along the way.

"He was unconscious. Blood was trickling from his left ear," the *Post* recounted. "If those negroes hadn't discovered the fire, those people would have been burned to death and the crime would never have been discovered," detectives told the *Post*. "Death [hers] occurred before the arrival of the ambulance, which was used to carry Joe Montione [*sic*] to the Norwood infirmary where he died at 11:30 o'clock," the *Age-Herald* added.

A black woman named Lillie Byrd was jailed and later convicted in the case, which police said was a dispute over a bill Byrd owed. However, the murders seem terribly similar to earlier cases and the many others that followed, although this was the only attack that involved a fire, the only one

where a child under fourteen was nearly killed and one of very few where a weapon was left behind.

Another axe murder with glaring differences to the other cases was discovered just three hours after the Mantione slayings. Mose Parker, a forty-five-year-old black man described as a recluse, was found dead, his head split open, in the backyard of his home in Titusville. His hat and shoes were found near his body, and police said he died long before he was found. Despite a lack of evidence, police said they believed it was not related to other cases.

In yet another act of violence that day, a night watchman at a coal mine company store shot a burglar who bored a hole through the floor, according to the *News*. The store had been hit three times before. Around 2:00 a.m., the watchman heard noises at the store and went to investigate. He waited until the man's head and shoulders came through the floor and then fired on him with his shotgun, "both loads taking full effect in the negro's body," per the *News*.

It was a violent end to a violent year, but it was nothing compared to what waited for Birmingham in 1922. The axeman would return less than two weeks into the new year, leaving two people dead and two others injured in two separate attacks in a span of fourteen days. Before the end of January 1922, the horror of the axeman's crimes would capture headlines and the attention of all of Birmingham, from its poorest immigrant miners to its richest white bankers. A growing sense of terror would soon spread across a city that was no stranger to murder and was quite ready to face it with whips, guns and nooses.

2

"AN OPENLY VIOLENT FRONTIER CITY"

Birmingham in the 1920s

Born in the ashes of the Civil War, Birmingham in the early twentieth century was growing faster than almost any city in America.

Founded in 1871 at the crossing of two booming railroad lines, Birmingham grew exponentially as steel mills rose from the earth, luring white and black sharecroppers from Alabama's cotton fields and immigrants escaping poverty. "Between 1900 and 1910 Birmingham's central growth rate was greater than that of any other major city in the United States except for Tulsa and Oklahoma City, and more than three times the rate of population increase in Atlanta and Houston," historian Blaine A. Brownell observed.

The infant city's wealth was buried deep beneath its soil, and thousands traveled across the state, nation and Atlantic Ocean to dig it out. Newly formed rail lines zipping to the West Coast from Atlanta through Jones Valley, the future home of Birmingham, helped drive the newborn city's rapid growth by carrying its freshly forged steel across the country, asserts Dr. Wayne Flynt, a professor emeritus of history at Auburn University.

"Birmingham was the only geographical area in the United States which had iron ore, coal, firing clay, limestone. Everything you needed to make steel could be found in the proximity of Birmingham," Flynt said. Four skyscrapers built on First Avenue and Twentieth Street North between 1902 and 1912 towered over downtown, and the intersection was forever

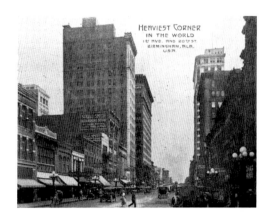

A 1925 postcard shows 'The Heaviest Corner in the World,' the intersection of First Avenue North and Twentieth Street, where four skyscrapers towered over the city. *Wikimedia Commons.*

dubbed "The Heaviest Corner on Earth." In his 1975 book, *The Urban Ethos in the South 1920–1930*, Brownell noted Birmingham's population grew from 38,415 in 1900 to 178,806 in 1920—a 365 percent increase.

The city was growing in diversity as rapidly as population. "Birmingham's percentage of foreign immigrants was one of the highest among inland southern cities," Brownell wrote. In 1920, 56.3 percent of the population was white, 39.3 percent was black, 3.4 percent was labeled "foreign born white" and another 1 percent was simply labeled "other." By the early 1920s, 30 percent of the city was Catholic, while Baptists made up only the fifth-largest religious group, setting it apart from other Bible Belt cities, according to Flynt.

"Birmingham at the time doesn't look anything like a traditional Southern city. By 1900, it was teeming with people. People from Italy, eastern Europe were pouring in to work in the coal mines. It was quite a different place and, of course, it was the quintessential new Southern city. Atlanta made the claim, but really couldn't back it up nearly as well as Birmingham could because Birmingham hadn't even been a town during the Civil War," Flynt asserted.

Despite the promise of growth, violence plagued the city.

In 1925, Birmingham had the nation's third-highest murder rate with 112 homicides—54.4 slayings per 100,000 people—just behind Jacksonville, Florida, and Memphis, Tennessee. The horror of the 1920s was unmatched until 1991, when 139 people were murdered, yet again making the Magic City one of the most dangerous in America. It's an image the city has struggled to shed, with some success, for more than twenty-five years. Flynt credits the "newness" of the city with driving much of the exploding homicide rate in the early twentieth century:

You don't have well-established social structures, neighborhoods, well into the 20th century and the best word to describe towns like that was disorderly. It would be not unlike cow towns like Dodge City, mining towns like Reno, Carson City, places like that. It was much the same culture; a lot of violence, a lot of sort of moving beyond the organized frontier where churches were weak, schools were weak, policing was weak. What you were left with was sort of every man makes his own law and enforces it, which tended to give rise to a high level of violence....Birmingham was in so many ways a frontier city.

"You stood almost three times as much of a chance of being murdered in Jefferson County in 1911 as you did during the drug wars in the early 1990s," says Jay Glass, a former chief deputy of the Jefferson County Coroner's Office who worked more than 3,500 homicides before retiring in 2008. "This was an extremely violent town, going back to the early 20th century. This was the Wild West; an openly violent town."

"In the 20s, you essentially have a lack of law enforcement, just in the pure number of officers. There was a high rate of black-on-black crime, which the police and legal system could not care less about," Glass mused.

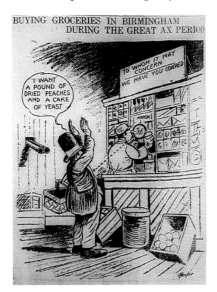

An editorial cartoon showed the extreme measures some merchants were taking. *From the* Age-Herald, *January 28, 1922.*

You have a lot of single men, white and black, and on Friday and Saturday night they are going into the city because there was a lot of free-flowing liquor, legal or otherwise, and there was a lot of gambling and lots of places of prostitution—they were illegal, but it was accepted. And, like now, everyone had a gun. You could buy one back then for a couple of dollars. A lot of homicides are related to the emotional reaction of the person and access to guns, but if they lack a gun, they'll find something else.

In the 1920s, with wood-burning stoves widely used for heating and cooking, short-handled axes were found in many homes and businesses

and were frequently used in violent acts across Alabama and the nation. As the Birmingham axe murders resumed in 1921, patterns emerged in the various cases. In several murders, police said victims were involved in bootlegging or buying stolen goods. Prostitution that crossed the race line—white men coupling with black women—was a factor in several cases, and good old-fashioned robbery likely drove many others.

"Bone Dry Alabama"

As Prohibition began, one of America's favorite pastimes became a criminal offense one could enjoy only by making booze or buying it from someone who might kill, either with a gun or a bad batch of whiskey. Alabama enacted its own prohibition law in 1915, and it was 1937, four years after national Prohibition ended, before the state followed suit and Birmingham steelworkers and miners could again look forward to a legally purchased drink.

Not that it mattered.

Soon after Alabama's prohibition began, people learned they could easily count on an illegally purchased shot of whiskey. After Alabama enacted prohibition, journalist Julian Street humorously noted:

> We met in Birmingham but one gentleman whose cellars seemed to be well stocked, and the tales of ingenuity and exertion by which he managed to secure ample supplies of liquor were such as to lead us to believe that this matter had become, with him, an occupation to which all other business must give second place....Since the State went dry, the ancient form, "R.S.V.P.," on social invitations, had been revised to "B.W.H.P.," signifying, "bring whisky in hip pocket."

Despite efforts to stop alcohol sales and consumption, Alabama soon fell under the control of bootleggers. "Thirty-five of the 57 federal criminal cases on the docket in early 1922 were liquor cases," Steve Suitts wrote in *Hugo Black of Alabama: His Roots and Early Career Shaped the Great Champion of the Constitution*. He also noted, "In 1921, almost 1,300 stills were smashed across Alabama and a million gallons of beer confiscated." While the federal government fought the flow of liquor, Birmingham officials looked to stop the expansion of the black community.

"A Substantially Black City"

Birmingham's black population was forced to live in places without sewers, street lights or police, Charles E. Connerly noted in his book *The Most Segregated City in America: City Planning and Civil Rights in Birmingham, 1920–1980.*

Birmingham had an African American population of 3,086 in 1880, which grew to 26,178 in 1890 and would triple in thirty years. "In 1910 and 1920, Birmingham had in its population a higher percentage of blacks than any other U.S. city with 100,000 or more population, and in 1920 Birmingham was the eighth-largest city in the nation in terms of black population," Connerly wrote. New Orleans was the only Southern city with more black residents than Birmingham. "From its very beginnings, Birmingham was planned not only as an industrial city but as a substantially black city."

Although they lived in a "substantially black city," Birmingham's African Americans reaped few benefits. "It was in the city's 'vacant spaces'—areas of undeveloped land bypassed for more pleasant sites by industry and white neighborhoods—that the majority of Birmingham Negroes settled. These black neighborhoods were generally settled along creekbeds, railroad lines, or alleys," Brownell explained. "The houses usually resembled the tattered and loosely constructed sharecropper cabins of the rural districts from whence almost all the Negro settlers had come."

The black community often lived and worked beside the immigrants who were viewed by the city's white Protestants with the same disdain as African Americans. Both communities could trust white police officers only to turn a blind eye to the crimes they often fell victim to or to treat them brutally when their paths crossed.

After the axe murders, officials implemented "the South's longest standing racial zoning law, lasting from 1926 until 1951," according to Connerly. The zoning ordinances kept blacks out of "white" neighborhoods and established one of America's most rigid systems of segregation, one lasting until Martin Luther King Jr. led marchers through the streets nearly forty years later. In the beginning, Birmingham's segregation was driven by morality, rather than race, as brothels and saloons were pushed into one ward, Flynt noted. "It wasn't a racial segregation, that wouldn't happen for a while, but segregating as in getting undesirables, as they were called, in the same area of Birmingham so decent people didn't have to go there and could warn their sons and daughters to stay away from there. That's where you had your saloons and the brothels," Flynt said. And of course,

A 1935 Walker Evans photograph taken for the Farm Security Administration shows miners' houses near Birmingham. *Library of Congress.*

these were the communities the city's poorest residents, often blacks and immigrants, would call home.

If segregation started off as a morality campaign, by 1930, it had evolved into a fully formed government-sanctioned system of racial discrimination. By that year, public transportation was racially segregated; the zoo and library were closed to blacks; and whites and blacks could not play dice or checkers together. The black community's opposition to the zoning ordinances focused on a fear of lack of resources, the black-owned *Birmingham Reporter* explained on January 15, 1923:

> *Some might get the impression that the Negro would oppose the bill because they desire to live with or near white people. Nothing is further from the truth. They oppose the measure because the Negro is unprotected when they are not near white people. They don't have police supervision, lights are not given, streets are not kept up and a general lack of interest is exercised in any absolute Negro community.*

The article shared the front page with reports on two axe murders, reflecting the dual concerns of race and crime. "An often unwritten assumption in the southern urban press was that most criminals and vagrants were black. Many commentators, in fact, explained the high incidence of violence in regional cities by pointing to their large Negro populations," Brownell wrote. "The white commercial-civic elite was most disturbed, however, by those cases of violence committed by blacks against whites, for it was here they perceived the greatest threat to the existing social system."

The axe murders were a threat Birmingham's power elite needed to neutralize, and the Ku Klux Klan was ready to help, marching at night through predominantly black and Italian communities. The Robert E. Lee Klan No. 1, founded in Birmingham in 1916, was "perhaps the most powerful klavern in the Southeast," according to Brownell. By 1924, the KKK claimed more than eighteen thousand members, including fifteen thousand of Birmingham's thirty-two thousand voters and two judges, "claims that were undoubtedly inflated," Brownell argued.

"After 1915, Birmingham became essentially if not the capital of the Klan, certainly the second capital of the Klan after Atlanta. It was probably the most Klan-dominated city in America," Flynt asserted. Brownell cited a historian who said Thomas Shirley, once Birmingham's police chief and later Jefferson County's sheriff, was a member, as were "most of the city's policemen, if not all of them."

Birmingham police chief Fred McDuff. *From the* Age-Herald, *January 29, 1922.*

"The power of the Klan continued to be felt in Birmingham several years after it had begun to fade in most other cities in the South and Midwest. Perhaps one reason was that in Birmingham it drew on the anti-Catholicism expressed so forcefully before the 1920s by a secret group called the 'True Americans,' which reportedly exercised considerable influence in city politics," Brownell wrote. It was a "True American" mayor who made Shirley police chief after removing his predecessor from office for being Irish.

Birmingham authorities wanted it known that law-abiding Caucasians had no reason for worry. "The circumstances in practically every case were brought about by, or partly so, the person murdered. I wouldn't hesitate to say Birmingham is freer from ordinary crime than any city of its

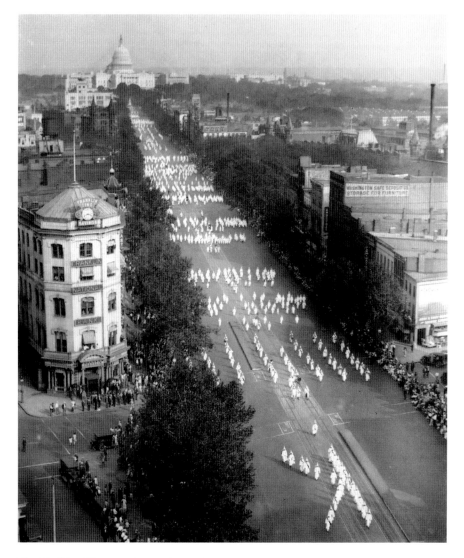

The Ku Klux Klan marches on Pennsylvania Avenue, Washington, D.C., in September 1926. *Library of Congress*.

size in the country," Police Chief Fred McDuff informed the *Age-Herald* in 1923. McDuff's words did little to soothe a city full of people arming themselves and looking for maniacs at every turn. The history of this young city was, after all, one of violence.

But not all of Birmingham's crime was violent.

"HUNDREDS OF DEAD BABIES IN THE TRASH"

In 1918, two Alabama military bases reported epidemics of venereal disease among soldiers who spent Christmas with Birmingham prostitutes and now filled three military infirmaries and, in some cases, were "ruined for life," the *Birmingham Ledger* reported. Secretary of War Newton Baker sent to Birmingham thirty military police officers with the power to enter any building at any time if they thought soldiers were there. Birmingham was eventually made off-limits to soldiers from those bases, Ellin Sterne wrote in her dissertation, "Prostitution in Birmingham, Alabama, 1890–1925."

Birmingham has a long, strange history with prostitution. In 1873, the newborn city was nearly wiped out by a cholera epidemic. As half the population fled, Louise Wooster, a downtown madam who claimed to have been a paramour of John Wilkes Booth, turned her brothel into a hospital and prostitutes into nurses. Wooster saved Birmingham and remains a popular figure.

While many cities shut down areas where prostitution was legally plied, Birmingham kept its police-protected red-light district until 1913. When that ended, residents complained prostitutes operated in the open city-wide—the headmaster of one elementary school threatened to relocate the campus because prostitutes worked the sidewalks outside classrooms during school hours. Corruption and a push to reform prostitutes led to a brothel crackdown. In 1923, W.B. Cloe, the city's public safety commissioner, addressed three thousand men at First United Methodist Church, Sterne wrote.

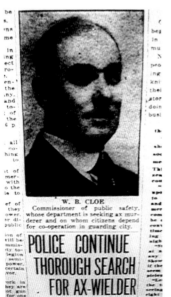

"We find hundreds of dead babies in the trash can in Birmingham, where their mothers have thrown them out when they were born illegitimately," he bemoaned. With Cloe's tacit approval, the Klan burned crosses in front of places where prostitution was practiced and threatened to flog the prostitutes and their customers to rid Birmingham of prostitution. In a city where the police department was dominated by the Klan, the white-robed men carried out their campaign with impunity.

Birmingham public safety commissioner W.B. Cloe. *From the Age-Herald, January 28, 1922.*

Father James Coyle. *Wikimedia Commons.*

Morality consumed public debate in the early 1920s. Public dances on Sundays were rejected in a hotly fought referendum; theaters agreed not to show films by silent comedy film star Fatty Arbuckle, as he was tried in a young woman's death; movies and baseball on Sunday were contentious social topics. The city endured hundreds of floggings—both by the Klan and by unorganized mobs that dragged people, men and women, into the woods, tied them to trees, beat them without mercy and left them naked and bloody in the dead of night. In one case, the health inspector was flogged by dairy workers angry at his crackdown on tainted milk.

Judge Leon McCord blamed Birmingham itself for becoming a "city of attacks" because all-white juries usually acquitted the suspects, Michael Newton wrote in *Ku Klux Terror: Birmingham, Alabama, from 1866–Present*. Residents "have no one to blame but themselves," McCord admonished. "The courts are no better than the juries that made them."

The KKK's power and cruelty was displayed on August 11, 1921, after Father James Coyle, an Irish priest serving Birmingham's Catholic diocese for seventeen years, officiated the wedding of Pedro Gussman, a Puerto Rican man, and Ruth Stephenson, a white woman. Stephenson's father, the Reverend Edwin Stephenson, a Klan member and Methodist minister who officiated courthouse weddings, found Father Coyle on the porch of the rectory and shot him in the head.

Stephenson was defended by Hugo Black, a thirty-five-year-old attorney and future U.S. Senator who wore Klan robes before donning a judicial robe as a U.S. Supreme Court Justice in 1937. With Black arguing both insanity and self-defense, Stephenson was acquitted. Birmingham Catholics commemorate Coyle's life each year on the anniversary of his murder. The city's federal courthouse is named in Black's honor.

"The Courage to Be Right"

Two months after Father Coyle's murder, Birmingham celebrated its fiftieth birthday as President Warren Harding visited the city. Harding angered the white establishment by using the occasion to become the first sitting president to voice support for civil rights while standing on Southern soil. "I can say to you people of the South, both white and black, that the time has passed when you are entitled to assume that the problem of races is peculiarly and particularly your problem. It is the problem of democracy

everywhere, if we mean the things we say about democracy as the ideal political state."

"Whether you like it or not, our democracy is a lie unless you stand for that equality," he added. While civil rights leaders and national news outlets praised the speech, the *Post* called it an "untimely and ill-considered intrusion into a question of which he evidently knows little." At a turning point in its history, Birmingham was not ready, it seemed, for Harding's ideas.

"If we are just and honest in administering justice, if we are alive to perils and meet them in conscience and courage, the achievement of your first half century will be magnified tenfold in the second half, and the glory of your city and country will be reflected in the happiness of a great people, greater than we dream, and grander for understanding and the courage to be right," Harding concluded.

President Warren Harding in Birmingham on October 26, 1921. *Wikimedia Commons.*

"Birmingham during the 1920s stood between the Old South and New, between the rural and the urban, between the past and the future, but the city clearly had one foot solidly forward and did not seem unduly hesitant to advance the other," Brownell wrote.

When Birmingham's "ax-wielding fiends" returned in 1922, they brought bloodshed and panic that threatened the city's forward march more than prostitutes, bootleg liquor or dancing on Sunday.

3

"A MANIAC WHOSE MIND RAN TO DEATH"

January 1922

As the coroner's men prepared to take her mother's bloody, lifeless body from the store, three-year-old Josephine Crawford let out a cry. "Mother, don't leave me," the child wailed. When she received no reply, Josephine threatened to sic the family dog on the men carrying the stretcher: "Doggie will bite!" It was January 11, 1922, and the child's parents, Clem and Alma Fenn Crawford, had just been slaughtered in their Avenue D shop on the city's west side.

Alma Fenn Crawford came from a prominent family in the Barbour County town of Clayton. Her surviving relatives included a Nashville doctor and an attorney in Washington, D.C. When the axeman visited her shop, she put up one hell of a fight. It was near closing time when someone ordered a bag of cornmeal. She filled the order while her husband and child slept in the other room. "It is thought she was struck over the head with an axe or hatchet while making change," the *Age-Herald* reported. However, the murderer only "struck a glancing blow [and] the fiend, not satisfied with the first blow, pulled a knife and cut her throat from ear to ear," the *News* contributed. But before he could reach the knife, Alma Crawford grabbed a chair and started swinging, striking her killer at least once with enough force to break the chair, pieces of which were found splattered with blood.

"Mrs. Crawford turned on her assailant and it was then he pulled the knife and cut her throat." Once on the floor, she was struck again with the axe, the blow crushing her skull. Police found her husband about four feet

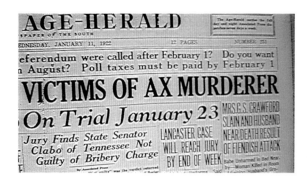

AGE-HERALD

WEDNESDAY, JANUARY 11, 1922 12 PAGES NUMBER 251

eferendum were called after February 1? Do you want
n August? Poll taxes must be paid by February 1

VICTIMS OF AX MURDERER

On Trial January 23

MRS. G.S. CRAWFORD SLAIN AND HUSBAND NEAR DEATH RESULT OF FIENDISH ATTACK

Jury Finds State Senator Clabo of Tennessee Not Guilty of Bribery Charge

LANCASTER CASE WILL REACH JURY BY END OF WEEK

Clem and Alma Crawford clung to life. *From the* Age-Herald, *January 11, 1922.*

away from her body. "The position of his body shows he was attracted by the noise and rushed toward the store only to meet a crushing blow on the head, which is believed to have fractured his skull," the *News* reported.

Clem Crawford lingered for about a week before dying at St. Vincent's Hospital. He, too, was from a prominent family; his father was warden of River Falls, a state-leased prison mining camp where inmates, mostly black, were rented out as cheap labor to coal companies. Like G.T. Ary less than two months earlier, the Crawfords were among the non-immigrant merchants joining the ever-growing list of axe victims robbed and killed in their shops.

The crime was discovered when a night watchman at a nearby business noticed the lights in the shop were off earlier than usual. Making his rounds again later, he grew suspicious when he saw the lights burning once again at 10:00 p.m., even though the shop usually closed at 9:30.

Police responding to his call discovered the house ransacked and dresser drawers covered in blood. A bag of the day's earnings—about $200—was missing. A dollar bill, perhaps one the killers gave Alma Crawford, was found near the woman's body. Her body was covered in newspapers and bed clothes. Had the killers wanted to spare her child that gruesome sight?

Josephine, reported to be unusually intelligent for her age, slept through the murders, only waking once officers arrived, and offered no clues. She was taken in for the night by coroner Jesse Daniel Russum, who lost both his legs in an accident as a teenager and his right ear in a 1917 train explosion. Dr. N.R. Baker, who later took the child in with his wife, Mrs. Crawford's sister, told the *Post* the couple had talked of leaving the business. "They were nervous because of the numerous attacks on people in stores," Baker said.

Two black men, John Pearson and William Eubanks, were arrested after two other black men told police they saw Pearson and Eubanks in front

of the store acting "in a very suspicious manner," the *Age-Herald* reported. A third black man, Will Cooper, was also later arrested, but all three were soon released for lack of evidence, the *Post* noted. Before they were released, a fourth black man was arrested at a park after he was supposedly overheard persuading a small group to break the murder suspects out of jail. "Talked Too Much," the *News* headline simply stated. The city offered a $100 reward, and the governor's office pledged a "substantial reward" for information about the murders.

Alma's remains arrived home to a grieving crowd gathered from across southeast Alabama's Wiregrass region, some 165 miles away from Birmingham. "Her gentle manners and her bright smile, her sweet disposition and absolute unselfishness, these and many other noble traits she possessed had made her a general favorite among our people," the *Clayton Record* mourned on January 20, 1922. "The Minister spoke touchingly of the beautiful life she had lived, made sad reference to her untimely departure from the world, but reminded friends and family that the separation was not final."

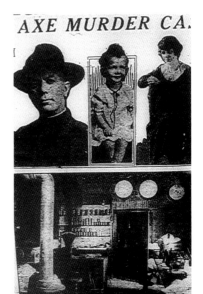

Clem, Josephine and Alma Crawford. *From the* Age-Herald, *January 12, 1922.*

In the hospital during his wife's funeral, Clem Crawford soon succumbed to his wounds and was buried beside his wife of seven years, his mutilated body accompanied by his Masonic brothers. "In the presence of a great throng of sorrowing friends and kinspeople his remains were laid to rest in the family lot in the Masonic cemetery, next to the recently made grave of his wife, side by side they had lived and faced death, just as side by side they will sleep till the resurrection morn," the *Record* reported.

Two weeks after the Crawfords were attacked, another Birmingham couple would together face the risk of death.

"AUDEMUS JURA NOSTRA DEFENDERE"

Bleeding badly from his head, Tony Lorino pulled himself from the floor of his Twelfth Street South grocery store and drew his revolver. His arm slung over the counter, Lorino fired wildly, emptying the gun at the man he feared was about to murder his wife and three young children. There is no evidence a single shot hit the axeman, but the chaos did attract Lorino's wife, Rosa, who ran in with their baby in her arms. It was January 25, 1922, and the axeman had struck again, once again finding himself face-to-face with someone who would fight to the death for their family, business and home. Their actions exemplified the motto adopted by the state a year after the assault—"Audemus jura nostra defendere," or "We Dare Defend Our Rights."

Rosa Lorino, forty-two, was hit with an axe or hammer, just as her husband had been as he served a "customer" moments earlier. The baby, Mike, was not injured, nor were the couple's other children, Francis, seven, and Vincent, four. The ordeal began around 9:00 p.m., when a black man entered the store and asked for some cornmeal, the *Age-Herald* reported. Tony Lorino later told police the man came in often and did not seem suspicious to him. He ordered fifteen cents worth of meal, which was at arm's reach, and then asked for a thirty-cent bag instead, which forced Lorino to bend over, the *Post* noted.

Fifty-year-old Tony Lorino, who "had a revolver in the bosom of his shirt," was hit in the back of the head when he leaned over. With Lorino in agony on the floor, the man then made his way toward the bedroom. As Lorino fired his gun, Rosa ran toward the store, their baby in her arms. She was struck in the left side of the head—her skull was crushed. As he ran from the store, the attacker struck the husband once more. Despite multiple blows to the head, Tony Lorino pulled himself up yet again and chased the man, grabbing a nearby shotgun and unloading both barrels at the fleeing figure. When police arrived, Tony Lorino was staggering around with the double-barreled shotgun while his wife was in a pool of blood in the kitchen doorway.

The next day, Rosa was unconscious and "at the point of death," while her husband was in critical condition, yet still able to speak to police. Both ultimately survived. "The entire locality is being combed by every available police and detective," said Assistant Chief Tom Christian, "and with every avenue of escape being watched the assailant is expected to be apprehended within the next 24 hours."

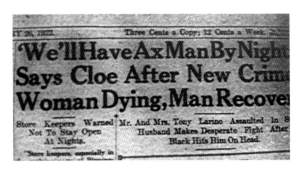

'We'll Have Ax Man By Night **Says Cloe After New Crime** **Woman Dying, Man Recover**

Store Keepers Warned Not To Stay Open At Nights.

Mr. And Mrs. Tony Larino Assaulted In S Husband Makes Desperate Fight After Black Hits Him On Head.

Store keepers, especially in

Police believed the axeman just within their grasp, according to Public Safety Commissioner W. Cloe. *From the* Post, *January 26, 1922.*

Even as the axe murders terrorized Birmingham, the city's police force appeared to be looking for more modern ways of fighting crime, although department leaders were quick to blame the victims. The day after the Lorino assault, public safety commissioner W.B. Cloe announced to the *Post* that the police department was adding more motorcycle patrols at night. "The city will be clocked off into squares and a man assigned to each territory so that no part of the city will be without police protection. This will be a big help."

Cloe also urged shopkeepers to close their stores at nightfall and to remain closed until sunrise. Though he said this was the most effective way to stop the crimes, it was not popular among merchants who relied on evening trade. "The situation is deplorable but it cannot be helped. We are meeting it as best as we can," Cloe said.

The situation was also being met by the Ku Klux Klan and an increasingly sensationalistic city press.

"THE WHITE ROBED PAGEANT OF THE MYSTIC ORDER"

The night after the Lorino assault, the Klan paraded through heavily African American neighborhoods. "Starting at Avondale at 8 o'clock, the white robed pageant threaded its way from one part of the city to another, visiting negro districts," the *Age-Herald* reported. "Activities of the mystic order lasted until 10 p.m." Police Chief McDuff welcomed the "nightriders," saying it was "suggested to him that activities of the Klansmen might be in order as a result of the recent series of brutal crimes." It may seem hard to believe today, but the Klan marches were accepted by police, perhaps because so many officers wore the white robes themselves and perhaps because officials, desperate to end the murders, were willing to try anything.

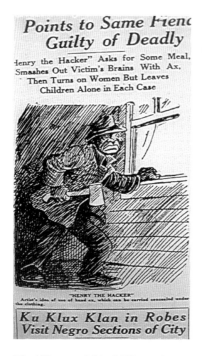

The killer was dubbed "Henry the Hacker." *From the* Age-Herald, *January 27, 1922.*

The KKK march was featured on the January 27, 1922 front page of the *Age-Herald*, as part of a two-day series of inflammatory stories about the murders that had claimed five lives in city shops in the previous two months. The articles told of Italian merchants arming themselves and forming an alliance, speculation by elderly blacks that the killer had mystical powers and a call by white merchants to "hang a few" black men.

They even gave the killer a name, "Henry the Hacker," in the caption of a crudely drawn, racist editorial cartoon. "Henry the Hacker asks for some meal, smashes out victim's brains with [an] ax, then turns on women but leaves children alone in each case," the caption read. The drawing shows "Henry" climbing through a victim's window, something the Birmingham axeman had never done.

"CRUSHED SKULLS, OOZING BRAINS, AND STREAMING BLOOD"

Was this sensational coverage reflective of the fear felt by residents or was it a cheap, cynical attempt by the *Age-Herald* to sell more papers than its many competitors? Either way, those papers represented the first significant public recognition that someone was chopping down immigrant families in city businesses. "The very fiendishness of the ax assaults convinces me that they could have been committed only by a hardened criminal and one with a police record of long standing," said Detective J.K. Jones. "The tendency in crime is to a gradual increase in the seriousness of the offenses committed and I believe that this man having committed one murder would not hesitate at another at the slightest opportunity."

And, of course, the immediate pool of suspects was the city's black population. "The negro sections of the entire city are being combed

through and no stone is being left unturned to apprehend the ax fiend," McDuff said.

If the coverage of the *Age-Herald* is to be believed, the entire city waited with bated breath for news of an arrest. "The axman is the topic of talk from the millionaire to the beggar….The city is a hub-bub of excitement and alarm over the deeds of what most concede to be a negro maniac criminal who is still at large." The articles compared the murders to the crimes of Jack the Ripper, who mutilated women on London streets more than thirty years earlier. The *Age-Herald* reports did their best to re-create the lurid details of the 1880s Whitechapel murders. "Behind each attack is evidence of shrewd and fiendish crimes of a maniac whose mind ran to 'death'—death by the ax—death which meant crushed skulls, oozing brains, and streaming blood."

Shopkeepers told the newspaper they were prepared to kill anyone who threatened them or their families. It was said that grocers were forming what the newspaper described as a vigilante group. "Storekeepers of Birmingham who keep open at night are fortified with weapons which they are willing to use." Condescending articles said the city's older African Americans believed bullets could not stop the axeman, perhaps to grab readers' attention with racist exaggerations that played on the stereotypes of the time. "Some of the superstitious and morbid types of blacks attribute superhuman powers to the 'hacker.' They think if a bullet from the revolver of Tony Loreno [*sic*] did hit the assailant that he is impervious to lead or steel."

One elderly black man suspected the axeman, like him, had the ability to survive gunfire. "Zed Thompson, a 91-year-old negro, states that lead never killed him, and that he has been shot many times and still carries the bullets in his body."

"KILL FOR THE VERY LUST OF KILLING"

Even so, merchants were more than willing to give guns a try if the axeman visited their stores. "Guns and guards! Everyone was united in the idea," the *Age-Herald* announced on the front page of January 28, 1922, the second straight day the paper would devote the bulk of its coverage to the murders. "Let us organize squads of men to hunt them down," butcher J. Rehberg said. "You better believe I don't turn my back on any customer these days. And I'm prepared with firearms, too."

While store owners were arming themselves, the "Ku Klux Klan has taken a hand and no one knows what may be concealed beneath their white robes," one article stated. Cooler heads called for citizens to pool money to hire guards and hold mass meetings to discuss possible solutions. Among the other ideas floated about:

"Stop everybody after 8 o'clock at night and examine them for any weapons they may have."

"Let squads of our men parade the town—in various sections of town—seeing that everything is all right till a late hour."

"It is the people's business now. The police have done practically nothing—or not been able to. It's the community's job."

"Let the Ku Klux Klan keep up its good work!"

"Hang a few!"

Women old enough to remember the Civil War said they too would take up arms to defend their homes and children just as they had against Union soldiers when they were young. "If we did it then, we can do it now."

"Citizens should assemble to try to prevent occurrences of this kind. It's the only way," said former police commissioner and longtime grocer T.F. Thornton. He recalled how bands of men in the late 1800s kept those with yellow fever from entering the city. "It ended the disease here. We got results when all the people got busy." Most who commented said they thought it was a lone black person committing the crimes, although others "felt there may be a dozen 'Henry the Hackers' being urged on to their crimes by a gang of white thugs"—perhaps one of the murderous Black Hand gangs active across America at the time.

The *Age-Herald*'s coverage was overseen by its principal owner, Edward Ware Barrett, who served as political secretary to Speaker of the House Charles Crisp before buying the paper in 1897. His son served as assistant secretary of state for public affairs under President Truman and founded the *Columbia Journalism Review* in 1961.

In his usual column under the pen name Ned Brace, Barrett described the axeman as having a mania "like unto that of the timber wolf who would kill for the very lust of killing. Evidently the negro who is doing this killing is in mental development but little above the ape with all the instincts of the brute." Barrett, as Brace, wrote that he ran the axe cases by a "noted criminologist." The scholar said some cases may have been the work of blacks and the others the work of whites. Barrett noted that ten years earlier, several "big stores…were looted" and there were several murders in the city because "fences"—those who bought and sold stolen

The exterior of the old Birmingham Age-Herald building at 2107 Fifth Avenue North as it appears today. *Author photo.*

goods—"did not tote square with the thieves," leading the thieves to respond with violence.

"This gang was broken up. But now Birmingham is inviting all classes from everywhere and the town is full of all sorts of criminals, both black and white," he quoted the expert as saying. Barrett signed off by reminding everyone to be careful, especially looking out "for any strange and unknown negro man."

"These Devils in Human Form"

While Barrett's news articles and column exploited the gory details of the bizarre murders and the raw nerves of racial discord, his official editorial stance called for a reasoned response. "Don't make Birmingham an armed camp," the editorial board proclaimed deep inside its January 28, 1922 edition. "There is no reason everybody should go about armed to the teeth. The practice of carrying deadly weapons has largely been responsible for the appalling list of murders and homicides which have brought discredit on this city. There is a law against carrying firearms and it will serve no useful purpose to violate that law."

Another short article in that day's paper included an appeal from the city's public safety commissioner. "This is no time for hysteria, but an occasion when every cooperation should be extended to the regularly constituted police authorities," W.B. Cloe said. The commissioner said his office was deluged with requests for gun permits, which he said would be refused. Vigilante groups, Cloe warned, would be arrested. "In the first place to carry a revolver is against the law. In the second there is no necessity for doing so. The life of the people is not generally menaced," Cloe reasoned.

On January 28, 1922, the *News* also spoke out against the KKK marches: "Terrorization of negro communities by nightriders cannot solve the mystery of the axe murders," the editorial board wrote. "Wholesale intimidation of the negro population, thousands of whom are honest and law-abiding and doubtless eager enough to bring the criminals, whoever they may be, to justice, cannot hope to further law and order in this community."

The "humiliating" demonstration of the Klan hurt efforts "to bring about harmony and understanding amongst all classes of our citizens," the *News* wrote. On that same editorial page, the *News* displayed its own failure to find "harmony and understanding" with the city's growing Italian population.

Days earlier, the *News* received an indignant letter from G. Milazzo after the paper suggested that Italians who did not cooperate with police and kept money at home rather than a bank were aiding the murderers. Remarking upon its love for such notable Italians as Dante and Michelangelo, the *News* suggested "that if every worthy and good Italian citizen in Greater Birmingham were as courageous in telling all that they knew of the pernicious Mafia and the blackhanders as the *News* had been in preaching strict justice to the offenders, all of us would have a stronger and more effective teamwork to help the police hound out the criminals."

The quality of police work in Birmingham, Milazzo wrote, "was very poor" and the *News* believed immigrants to be "ignorant, as they never say anything, thinking that the law will take its course in apprehending these culprits and giving them justice as is done in foreign countries. If the *News* would be fair it would quit making these remarks and put more stress on the police department and the people as a whole in an effort to round up these devils in human form."

To round up those devils, Birmingham police would soon resort to mystical means.

THE OUIJA BOARD AND A TRAIL OF BLOOD

Three nights after the attack on the Lorinos, Birmingham police chased down a clue mailed to them by an anonymous Montgomery letter writer who said the information came to him as a group played with a Ouija board, according to the *News*. The letter had been received that Saturday afternoon by Police Chief Fred McDuff. "One of the parties, while the board was not in action, suggested that the Birmingham axe murders must have been committed by an insane or deranged person," the *News* reported on January 29, 1922. The letter writer said as they began to play with the board, the planchette formed a message: "The negro that committed the axe crimes did so maliciously and is cooperating with others," the board supposedly told them.

The board then spelled out the name of "a Birmingham criminal negro known to police"—a name the letter writer claimed not to know. The *News* agreed with McDuff's request not to print the name. "There may be absolutely nothing to this message," the writer said of the Ouija board, "but if there is a negro by the above name in Birmingham it would do at least no

harm to investigate his actions." Assistant Chief Tom Christian dispatched some of the department's "ablest detectives" that night to search for the man, but they came up empty handed. The *News* noted that investigators in Europe had begun employing psychic experts to "aid regular sleuths in running down criminals."

McDuff suggested perhaps the Ouija board was a ruse or "novel instrumentality" by the letter writer to tell police what they knew of the crime. The writer of the letter said they did not include their own name to avoid "much unpleasant notoriety." McDuff noted that the writer, in his opinion, was an educated person.

Earlier that day, in what was likely unrelated to the Ouija search, a motor scout arrested "Clarence Bly, half-wit negro," the *News* reported. Bly was a suspect in the Lorino case but also a "puzzle to city detectives." Bly lived alone in a Northside shack where police found a bloody chisel, a razor, a hatchet and a revolver. Police said Bly "was just the type of negro" that might commit such murders. However, Bly was cleared when it was learned he cut himself while making washboards. "Had he been of normal mind, he could have explained the blood stains on the hatchet so that it would not have been necessary to place him under arrest," McDuff said.

"Bring Them to Justice"

Hours after detectives went on their Ouija board–led goose chase, "law abiding Italian citizens of Birmingham" gathered at the chamber of commerce auditorium, the *News* reported. The Italian Protection Association was formed that Sunday afternoon. "It is not intended to do anything that will in the least hamper the work of the officers of the law but to bring about such assistance that will result in the arrest and conviction of criminals of all kind."

While the group planned to build "respect for the law and patriotism," members also intended to "hunt down criminals and bring them to justice or cause them to leave the district." The group would also "furnish funds to hire detectives or to do anything necessary to arrest and bring to justice criminals who have in any way attacked members of this society." The Italians of Birmingham were no strangers to discrimination and violence, but as 1922 began, it was clear they were not going to be victims—not without a fight.

Birmingham's Italian population had grown tremendously in thirty years, from 130 in 1890 to 2,160 by 1920. Although the largest immigrant group in Jefferson County, Italians accounted for less than 1 percent of the population, historian Robert J. Norrell wrote in his 1980 booklet, *The Italians: From Bisacquino to Birmingham*. Bisacquino, a small farming town home today to about 5,000 people in the southern Italy city of Palermo, was the source of much of Birmingham's Sicilian population in the early twentieth century. As Italians were forming a community in the early 1900s, they faced widespread scorn and threats, particularly those with darker complexions.

"It is a well-known fact in history that the Spaniard, the Italian, the Greek and the Assyrian have mixed their blood with the races of Asia and Africa for many generations past. They are not of the pure white race and when we mix with them we are not of the pure Aryan race," Birmingham's congressman, Oscar Underwood, declared on the floor of the U.S. House of Representatives in 1905. Despite facing adversity from the halls of power to every dark alleyway, Italians built a community that thrives today, their descendants serving in public office and growing businesses their great-grandparents built. While Underwood fought in Washington for literacy tests for immigrant voters, Italians in Birmingham faced adversaries far closer to home.

The morality movement of the early 1920s led to city leaders passing ordinances banning Sunday movies, dancing and baseball—a direct affront to the immigrants' culture. Like all good Alabamians, Italians dared defend their rights by appointing lookouts during Sabbath ball games to yell for players to scatter when police rolled up. One man built a tall fence around his backyard so he and his neighbors could play bocce, their homeland's favored sport.

Much like African Americans, Italians lived in fear of the KKK, who might drag them from their homes and whip them for any reason. "The K.K.K. was after the bootleggers and our street was the main street," Rose Maenza told Norrell. She was one of many frightened children who peeked from under their curtains during nighttime Klan parades. "When they went out there at night we'd hear them coming—the swoosh of all those cars going by late at night. When we saw them, we tried to hide under the bed. We were scared."

4

"HE REJOICES IN BREAKING THEIR BONES"

February–November 1922

Greater Birmingham in all her 50 years of more or less spectacular history has never before been so close to the border line of hysteria as at present," George W. Graham, special correspondent to Montana's *Great Falls Tribune*, wrote on February 5, 1922. "Psychologists, criminologists, hard-headed detectives, experienced policemen, Ku Klux Klansmen, soldiers of the world war, even the Ouija board, are unable to ferret out the causes of a series of ax murders and assaults that have set the Birmingham's districts nerves on end."

And, just like that, the bloodstain of the axe murders spread 1,500 miles from the front pages of Birmingham's newspapers to papers around the nation. "Negroes, upon whom the police depended for cooperation, keep at home and have closed up like clams" because of nighttime Klan rides, Graham wrote. "They do not venture out, neither do they talk."

Graham noted that in many of the murders, at least one victim was a "woman, young and pretty, leading to the belief that the work was that of a sadist, one of the most dangerous of all perverts and mania cases." Graham included that local experts—professors at two of the city's largest private universities, still operating today—believed the fact children were left unharmed added credence to the sadist theory:

> *Dr. William T. Bohannon, head of the Department of Psychology at Howard College, who has carefully investigated these crimes, says that the sadist does not molest children. The sadist, he declares, delights in*

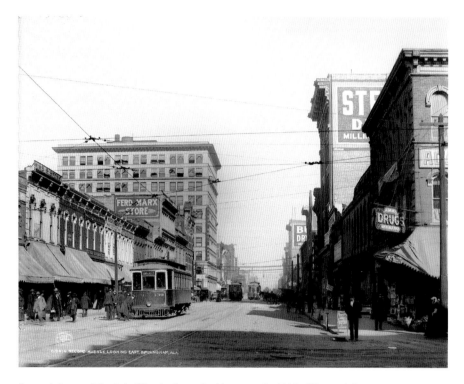

Second Avenue North in Birmingham, looking east, in 1906. *Library of Congress.*

seeing young women, particularly young and pretty ones, suffer. He rejoices in breaking their bones and watching them welter in their own blood. [Howard College long ago became Samford University.] *Roy T. Hoke, who holds a similar position at Birmingham Southern College, also holds the opinion…that the ax wielder would commit further and even worse assaults if he were not found and confined.*

So much excitement exists that various organizations and individuals are bombing the commissioner of public safety with offers to help solve the mystery. The American Legion has taken a hand and asked the police department to permit a civilian-soldier guard to aid the police in stamping out the terrorism.

"A NEGRO HIGHWAYMAN MASQUERADING AS A WOMAN?"

The wig baffled detectives most of all.

Police called to Simpson Methodist Church on March 27, 1922, found a white man and a black woman behind the building in puddles of blood about fifteen feet apart. The white man, who they could not immediatcly identify, had in his pockets $1.01 and a two-day-old Pullman train receipt from New Orleans. The black woman was forty-year-old Ida Lewis, someone police supposedly knew quite well. The two were discovered "lying in pools of blood with their skulls crushed," the Talladega newspaper *Our Mountain Home* reported. A pipe wrapped in a blood-soaked white cloth was found not far from a wig by a fence along Seventh Avenue North and Twenty-Fourth Street.

Police quickly concluded the wig did not belong to Lewis—who was found in a "dying condition" but would ultimately survive. The white man, later identified as construction foreman Russell Kellum, thirty-nine, died about eight hours later at 4:40 a.m. that Tuesday morning. He was survived by his parents and six sisters. What brought together a white man and black woman behind a church on a Monday night? Who attacked them? Who did the wig belong to? Two days after the attack, the first of its kind in two months, the *News* asked whether Kellum "was slain by a negro highwayman masquerading as a woman?"

Police were "of the belief that the wig was worn by the assailant of the two and they are equally positive that the assailant was dressed as a negro woman," the *News* reported. It was thought as many as three people took part in the crime, based on the number of footprints in the mud. "A negro man, whose name I do not know, came to my house last night and said that he was passing by and heard groans and wanted me to go outside and see what the trouble was. We both went out on the lot and found the two unconscious. We immediately notified police and called an ambulance," said a man named V. Wahn, who lived nearby.

Lewis was found with an injury newspapers said looked like a gunshot wound. Kellum, said to carry large sums of money and travel frequently, was found with his pockets turned out. "When discovered, Kellum's body was lying 15 feet from that of the Lewis woman, partly immersed in a pool of blood with his head crushed in from blows with a piece of heavy lead pipe, found near the scene." S.H. Dooley of the Southern Road Company said he was friends with Kellum and last saw him with a white woman hours before

his murder. Dooley said Kellum stopped at a store and bought a newspaper. Though Kellum's friends lost track of him at this point, they all agreed he was looking for booze. "Where did his woman companion go when the attack occurred? Or was she with him at the time?" mused the *News*.

Police believed Kellum met up with Lewis to buy some whiskey, the *Post* reported. "Lewis, the negro woman, is well known to the police. The city welfare department removed from her care three children by a former husband on grounds she kept them improperly. She has been arrested several times on disorderly conduct charges." Disorderly conduct charges and a twenty-five-dollar fine were often levied when Birmingham police found black women alone with white men.

The search for alcohol apparently led Kellum and Lewis to the rear of the church, where police believed Kellum sat down on the back steps and made the fatal mistake of flashing the cash he brought back from New Orleans. "They [police] argue that the man was attacked first and that the woman knew the assault was coming from the fact that she did not scream or try to escape while Kellum was beaten over the head repeatedly with a blunt instrument," the *Post* reported. Lewis was then attacked, "her head beaten to a pulp," to keep her quiet, police said.

Moments later, Fred Perryman, a special agent with the St. Louis–San Francisco Railway railroad police, saw two black men, one carrying a bundle, running through a nearby park. "Rigid investigations of the movements of the Lewis woman were in progress today but were admittedly revealing little of value. They have been unable to connect her with any man who might be suspected of the attack either from the motives of jealousy, revenge or robbery," the *Post* continued. "This case, unless by a miracle the Lewis woman recovers, bids fair to take its place with the other unsolved murders of which there have been a record number in the last few months."

Days after the attack, two black men suspected in the crime, Sadie Howard, nineteen, and Charley Ware, twenty-five, were arrested "under the dangerous and suspicious ordinance," according to the *Post*. What happened to them remains a mystery. As the murders continued, the case of Kellum and Lewis was, for whatever reason, never mentioned again in the growing list of victims that would accompany reports of each new act of horror.

However, the murders must be recorded among the city's axe spree because they marked the beginning of a horrifying new chapter in the case. For the first time, white men and black women in city alleyways, not immigrants in stores, were the targets of an axe murderer. Kellum and Lewis would not be the last. But that didn't mean the killer, or killers, were done with merchants.

"SUMMONED BY HER SCREAMS"

The axeman staggered into the sweltering summer night, the woman who moments earlier made him an ice cream cone swinging from his neck. Lena Lucia's husband, fifty-year-old Joe, had whipped up for their "customer" a Coney Island dog at their shop at 2005 Jasper Road on June 3, 1922. Hot dogs covered in a chili-like beef sauce were once a staple of the blue-collar Birmingham diet, served in Greek-owned storefronts now sadly all but vanished. When Joe and Lena turned to get the food, they were struck with an axe; Joe was instantly knocked unconscious. But, like so many women in the axe cases, Lena was not going down without a fight.

"Evidently the negro was frightened away from his intended loot by the screams of Mrs. Lucia, who retained consciousness despite the terrific blow she received, as the money drawer was undisturbed," the *Age-Herald* reported. She "clung to the negro's neck, which frightened him, and he evidently dragged her out of the store where she was found by neighbors, summoned by her screams." The attacker hit her again and ran away. Her husband "was found prostrate behind the counter in a pool of blood, from the deep wound in his head."

The owner of a nearby store, Mrs. Vassar, said she saw Lucia's attacker run from the store, recognizing him as a man who was in her own store shortly before the assault. "Mr. Vassar is of the belief he and his wife were the intended victims of the ax-man although he was frightened away by the arrival of two additional men in the store."

"Police declared Lucia's life and money were saved by his wife who attacked the negro so fiercely after he struck Lucia that the black fled," the *Post* disclosed on June 4.

"WITH THE WHIP AND ROPE"

Tempers flared at city hall three days later as city leaders debated forbidding Ku Klux Klan members from wearing white hoods in public. Klan leaders were quick to note that axe assaults on city merchants resumed after a months-long absence, between the attacks on the Lorinos in January 1922 and the Lucias in June 1922, just as prominent citizens began speaking out against the KKK. "Recently here in Birmingham you had a series of ax murders. There were parades one night of white-coated figures. The

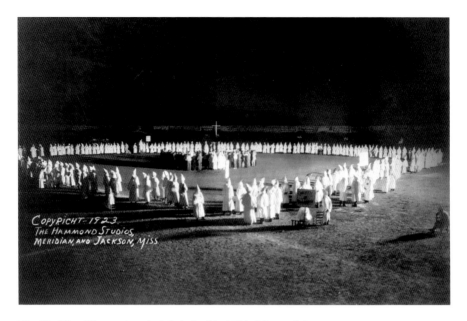

The Ku Klux Klan gathers in Mississippi in 1923. *Library of Congress.*

ax murders abruptly stopped. But since this tirade of abuse has been let forth, just last Saturday night you had another ax attack. These facts are indisputable," said Atlanta's Reverend F.J. Mashburn, a Klan spokesman.

Klan marches through the city were welcomed in January, but by the summer, they were the subject of intense scrutiny. "I think it is one of the most dangerous things that has threatened Birmingham in years," said W.V.M. Robertson, president of the Community Club. Mashburn vowed the Klan would fight to keep the white race "pure" despite all criticism and that "no matter how much you persecute us, it makes us grow faster."

When Mashburn implied the Klan would respond with violence if they could prove someone made untrue allegations against them, a seventy-five-year-old white man decided he had heard enough.

"If you can't prove it, what are you going to do?" asked Captain Frank S. White.

"We will proceed," Mashburn said.

"With the whip and rope, I suppose," White replied.

Born in Prairie Point, Mississippi in 1847, White was a Confederate officer under Nathan Bedford Forrest, the Klan's first "Grand Wizard." As a teenager, White was a prisoner of war in Selma in 1865 as Union general James H. Wilson's Raiders destroyed ironworks across Alabama.

After the war, White returned to Mississippi and became a lawyer and a powerful political figure. In 1886, White saw the promise of booming young Birmingham and at age thirty-nine established a law practice here. In 1914, White became the first man in Alabama elected to the U.S. Senate by a direct vote of the people.

After leaving Congress, White led the city bar association's fight against the Klan. "Who gave you the right to interpret the constitution? We can control the negro without your help from Georgia. What state in the union is more disgraced by lynchings than Georgia? You say you are cooperating with law and the constituted forces of law. Have you caught one [lyncher] and has there been one of these lynchers apprehended?" White asked. Mashburn said the Klan was not interested in lynching, that it was "a band of men sworn to uphold the flag against all comers.…[I]f you could see the personnel of the Klan in Birmingham, you'd be surprised."

They may have been proud of their work, but many men in the ranks of Birmingham's Klan wanted their faces shrouded during their nighttime parades. A cheer let out in city hall when the unmasking ordinance was voted down. White died less than two months later on August 1, 1922.

"When the Trail Is Hot"

As the summer of 1922 ended, the murders that began the previous November seemed to be ending after nearly sending the city into pandemonium. Then, on September 30, 1922, sixty-year-old shopkeeper J.H. Seay was badly wounded on a Saturday night at his grocery store at Thirty-Ninth Street North and Thirty-Fifth Avenue North, the *News* reported. "Seay was found unconscious lying in front of his store at 7:30 by employees of the Sloss By-product plant." The store was ransacked, the registers emptied and Seay's money and watch were gone, but no clues were left. Seay remained semiconscious for several days but later recovered. He told police he couldn't remember the assault, which left him with a gash from his forehead to his ear. He "talked disconnectedly of being robbed and was said to have insistently inquired of two men with whom he was acquainted," the *News* noted. "Sometime ago the city was stirred by a series of ax crimes under circumstances similar to the attack on Seay."

The day after the Seay assault, the *Age-Herald* confirmed Jefferson County coroner J.D. Russum was urging the city to create a homicide investigation

squad, a band of the city's best detectives, to immediately respond to murder scenes, day and night, all year round. It was a request the commission would quickly grant. "No one comes in closer contact with crime than I do and no one realizes better than I the importance of getting men quickly to the scene of a crime when the trail is hot," Russum said.

Russum was born in Elbert County, Georgia, in 1874, Sharon Davies wrote in *Rising Road: A True Tale of Love, Race, and Religion in America*. As a teenage dropout working in a furniture factory, an accident cut off both of Russum's legs. Finding success as a traveling salesman despite his injuries, Russum married and, in 1907, moved to Birmingham with his wife to raise their five sons. The future coroner quickly won the love of his Birmingham neighbors who, as one put it, made them "ashamed of complaining against small discouragements."

In 1917, Russum was traveling aboard a train pulling into Birmingham's Woodlawn neighborhood from New York when a fellow passenger got up from his seat. L.D. Walton, accused of murdering his business partner for insurance money two years earlier and freed after a mistrial, stepped into a railcar bathroom. Outside the door, Walton left a note: "See my suit-case for important papers."

A blast ripped through the Southern Railway's Birmingham Special, shattering windows, bending the railcar frame, tearing Walton's "body into a hundred bits," killing two other men and injuring more than a dozen people. The blast was believed to have been caused by nitroglycerin; some survivors said Walton carried a glass bottle as he boarded the train. Russum, described as "a cripple before the explosion," was left "in a serious condition at the hospital, his right ear blown off and his head gashed, a large splinter in his side and [what was left of] his right leg fractured," wire reports stated on January 11, 1917. Walton had days earlier taken out a $10,000 life insurance policy with a double indemnity clause in case of death on the railroad.

In 1920, Russum made national news again, this time as the "no-legged man" who sought office in Alabama and was elected Jefferson County coroner by a wide margin. The Associated Press giddily reported Russum had successfully "stumped" for votes.

Jay Glass, who spent more than thirty-five years in the Jefferson County Coroner's Office, said he believes that because the coroner's office was still an elected position at the time, Russum got the job because of sympathy from politically powerful friends rather than any skill or experience in investigating deaths. "All you had to do was get on the Democratic ballot. It wasn't a highly sought-after position; it was probably one level above a dog

catcher. People probably felt sorry for him because he had lost his legs, so they made him coroner."

After his election, Coroner Russum battled with the press, who resented his closing access to witness interviews, Davies wrote. At that time, it was the "no-legged," one-eared coroner who interviewed witnesses and murder suspects, presented findings to a judge and sought warrants that sent men to prison or their deaths—all tasks handled today by detectives of the homicide squad Russum helped create.

When Father James Coyle was murdered, the newly elected coroner silenced skeptics who believed the Klansman killer of an Irish Catholic priest would never see the inside of a courtroom. A day after the murder, Russum subpoenaed about seventy-five people, Davies wrote. The next day, Russum appeared before a judge and swore out a first-degree murder warrant, asserting the Reverend Edwin Stephenson had "unlawfully and with malice" killed Father Coyle. A jury would quickly acquit Stephenson.

In 1928, while serving as coroner, Russum was named acting Jefferson County sheriff for four months after Sheriff Chris Hartfield died following a brief illness. Russum, who lived to be about seventy, opened his home to orphans of murder and pushed for resources to conduct thorough death investigations. Whenever you are reading this, day or night, detectives in the Birmingham Police Department Homicide Division that Russum helped form are investigating murders and waiting for the next "signal 9"—the city police radio code for a death.

Weeks after forming, the five-man homicide squad would "test its mettle" against the axe killers. However, when detectives investigated the next two axe murders, they ran into a problem their modern-day counterparts battle on the streets today: no one cared enough, or was brave enough, to talk to police.

"THE OFFENDING PIECE OF THE SKULL"

Julius Silverburg, a white, twenty-year-old telegraph operator for Western Union, was caught with a black woman, Louise Carter, on a Saturday night, October 21, 1922. "Police charge the couple apparently went into the alley for immoral purposes," the *Post* reported. "When officers arrived, they found the couple lying in a pool of blood, less than two feet apart," the *News*

added. "The woman was lying on the ground with her clothes disheveled," according to the *Age-Herald*.

Nearly seven months after Russell Kellum and Ida Lewis were slain, it appeared another white man and black woman had been struck down in another Birmingham alley.

"Her body was swollen, the detective said, and considerable difficulty was experienced in identifying her. The woman's brains had been dashed out from a terrific blow to the forehead. Silverburg was found sitting against the door of the garage, in a half-conscious condition from a blow on the back of the head," the *Age-Herald* added. Carter was dead; Silverburg would linger on in agony for eight days.

"Detectives of the homicide squad declared they were meeting with a difficult task of locating the murderer of the woman and the assailant of the white man due to the lack of interest being displayed by the public," the *Age-Herald* report continued. "Due to the conditions surrounding the murder, the white population of the city have virtually assumed the position of 'hands off,'" said Sergeant W.L. Brannon, head of the homicide squad. The black population, he added, showed "utter indifference" as to whether the killers were caught.

Silverburg and Carter were not found until six o'clock Sunday morning, when two people who lived nearby saw them lying in puddles of blood outside the garage. Although a group of black people lived in a shack fifty feet away, they heard no sounds and learned of the murder only when police arrived, the *News* related. Though police said robbery was the motive—Silverburg's pockets were turned out—his killers left him with a sizable diamond stick pin and a ring. Near Silverburg was a copy of *The Forty-Five Guardsmen*, a novel of political intrigue and swordfights by French author Alexandre Dumas, the story of a group of lower class noblemen called to serve and protect King Henry III and, later, King Henry IV. In Silverburg's pockets were letters indicating he had family in Montgomery.

Silverburg was taken to South Highland Infirmary, but he was of no use to detectives. An X-ray showed Silverburg suffered two skull fractures, likely caused by one blow. "Silverburg is paralyzed over his entire left side and vocal organs," the *Age-Herald* reported. Two days after the attack, Silverburg could move his head and an arm just enough to answer detectives' questions. At first, he indicated he could identify his attacker, but he could not.

Doctors said they were considering removing an "offending piece" of his skull, which was pressing down on Silverburg's brain and was expected to kill him. Whether they did, he died all the same.

The Ku Klux Klan assembles a short distance from the U.S. Capitol with the American flag as their banner sometime between 1920 and 1930. *Library of Congress.*

"The weapon was not found at the scene," the *Age-Herald* reported, "although a piece of brown wrapping paper, covered with blood, was found a few feet down the alley from the spot where the two people were found." Hours before the murder, someone reported to the police a black woman near where the two victims were later found. The woman matched Carter's description and was said to lure white men into alleyways so a black man could rob them, the *News* claimed. Detectives patrolled around 10:00 p.m. Seeing nothing, they moved along at 10:30.

Detectives also told the *News* that "the crime could have been the result of an organized effort on the part of negroes of Birmingham to suppress intermingling of the races. Or, it could have been the work of a negro fanatic, working singly with the same object in view."

The object nearly two thousand KKK members viewed two nights later was a massive cross burning at Birmingham's first airfield, Dixie Flying Field, as seven hundred new Klan members were initiated. The *Post* reported another four hundred spectators watched the ceremony lit by the fire of the cross. "White civilization will be made secure by the activities of the Klan," the Reverend Samuel Campbell, a speaker from Atlanta, said. "The unnaturalized foreigner in our midst is a threat to America."

"THE WRONG KEY"

Abraham Levine, a forty-year-old father of five, told the stranger that the house adjoining his family's store was not complete and not for rent. The man insisted the door was open, so Levine grabbed the key and followed the man out. "A few moments later, the negro returned and told Mrs. [Sarah] Levine that her husband had taken the wrong key. Mrs. Levine then took a key and went out," the *Post* reported.

Minutes later, the stranger returned and bought a half dozen eggs for twenty cents from their daughter Emma, who was either fourteen or sixteen. When she asked where her parents were, he calmly replied, "They are in the back of the store; they're all right," according to the *News*. Emma suspected something was wrong and began to scream. Her uncle, Jake Levine, heard the screams from his store on the opposite corner of the street, ran to help her and found his brother and sister-in-law in pools of blood.

Sarah was on the back porch; Abraham had staggered and fallen in a potato patch about thirty feet away. Both were struck in the head with an axe. Abraham's pockets were turned out, and fifty dollars his daughter said he had carried was missing. A blood-stained sack of eggs was found on a nearby sidewalk, the *News* reported. Police told the *Post* they believed a second man hiding inside the house struck the couple when they went

Emma Levine pictured in the *News* in November 1922. *From the* News.

with the stranger to lock the door. Abraham was the victim of two other robbery attempts in the sixteen years prior, but in each case, the robbers had been scared away.

Detectives said they also believed the man returned to the store after Abraham and Sarah were attacked to kill Emma so she could not identify him. However, another customer was in the store, likely foiling the plan. Abraham, struck in the left side of his head, was left with a three-inch-long gash and a fractured skull, per the *Age-Herald*. He died two days later, but Sarah recovered, despite her severe injuries and intense pain.

This visit by the axeman to 1600 Fourth Avenue North on November 6, 1922, was a "renewal of the worst phase of the crime wave that has swept Birmingham for nearly two years—ax murders,"

the *Post* reported. The crime wave included floggings, bombings stemming from a railroad strike and "firebug robberies"—burglars setting fire to homes they looted. "Chief Fred McDuff issued a warning to the proprietors of small stores that dot the negro sections of Birmingham to close their doors at dark and not to re-open until after sunrise," the *Post* announced. The Levine family offered a $1,000 reward in the case.

Less than three days after the attack, police arrested two black men, John Harris, who was found with several hatchets when he was apprehended, and Spencer Clemmons. Emma and her sister, Gertrude, identified Clemmons as the killer, police told the *News*. It is not clear what happened to Harris, but Clemmons was put on trial in February 1923. Tears streaming down his face, Clemmons testified he was home all night when the Levines were killed. A jury of all white men acquitted Clemmons.

"I am a good Negro and would not harm anyone. Gentlemen, I will never forget the justice you have shown me in this case. I had a terrible crime laid at my feet, one that I knew nothing of. But you have given me justice," he told the jury in remarks shared by the *Reporter*.

"WRITTEN IN BLOOD…THE PLAIN STORY OF TRAGEDY"

January 1923

His hands tied in front of him, John Robert Turner bounded down the front steps of Lilly Bell's house and into the night.

The white, twenty-four-year-old house painter made it only a few feet before an axe crashed into the back of his skull and sent him sprawling to the ground. Bell, a forty-five-year-old black woman, was found in the alley about forty feet from her house. Bell's hands were also tied, and she had been struck in the head multiple times with an axe. The assailants took the weapon with them, possibly after they were convinced she was dead.

Turner, found with money still in the pocket of his blood-soaked clothes, suffered three blows that fractured his skull and soon died at St. Vincent's Hospital. Bell was taken to Hillman Hospital, reportedly survived and told police the attacker was a black man, but said she could not identify him or the weapon used. It was the night of January 6, 1923.

"Saturday night's assault had the appearance of having been planned with the object of torturing the victims before they were killed. Then, apparently, something occurred to frighten the assailant and he proceeded to attack his victims with an ax without further delay," the *Post* reported.

Newspapers speculated prostitution brought together Turner, a white man, and Bell, a black woman—the papers reported that she had a police record, although it was not clear for what offense. Such pairings, the press suggested, had drawn the bloody ire of a clandestine group of blacks. "Is there in Birmingham an organization of negroes for the purpose of exterminating negro women and white men suspected of immoral relations?" the *Post* report asked.

It seemed there was a growing sense, shared publicly by white lawmen and the city's black-owned newspaper, that a gang of African Americans were attacking white men and black women they caught together in alleys. If not approved of, it was treated as a reasonable reaction to people "crossing the race line."

"Indications that this killing—the fifth of a series of slayings involving white men and negro women—was the work of an organized band of negroes who are seeking to stop immorality between the races were strengthened today by an anonymous letter to The Post, which was turned over to the police." The note, according to the article, warned young black women to stay away from white men or face the wrath of the "ax-man."

The black-owned *Birmingham Reporter* believed black vigilantes committed the murder after they "decided to do away with Negro women and white men who would indulge in crossing the line and defiling both races by such practices."

Four nights later, there was another vicious attack, this time in the feed shop of a Russian man who had lived in Birmingham for eight years.

"THE AX DESCENDED ON HIS SKULL"

It was January 10, 1923, just before 7:00 p.m., at fifty-five-year-old Joseph Klein's shop at 1406 Eighth Avenue North, when he and his daughter, fourteen-year-old Ethel, joined the seemingly never-ending list of victims attributed to Birmingham's "ax wielding fiends."

"Someone came into the building, turned off the lights and beat [Joseph Klein] over the head so badly he died at midnight at South Highlands Infirmary without ever regaining consciousness," the *Post* reported. His pockets had been emptied. "Judging from the wounds, Klien [*sic*] was struck while facing his attackers. There were two gashes horizontal on the forehead and others on the top of the head. The girl's head was also cut instead of bruised."

Ethel, badly wounded, ran to a nearby drugstore, crying for help, her head and face covered in blood. Newspaper articles recounted what Ethel, one of the youngest of the axe victims, told detectives between "fainting spells" and in broken English.

I was in the back of the store. My father was in the front. Suddenly the lights went out. The switch is on the right hand side of the front door. I

heard sounds of a struggle in the front. Then I heard my father groan and the sound of blows. Then I heard something fall. I was too frightened to scream. I stood still for a moment. Then I went on up toward the front. Then they put me to sleep.

But Ethel Klein survived.

Her mother was not told of the death until hours later, thinking her husband had only been injured, because of "relatives fearing the shock would prove serious." Ethel later said her father's attackers had faces that were "exceptionally white."

"White, white, pale you know, like toothpaste," she said. "This color of complexion is the mark of the drug addict, according to physicians, and it was this statement that sent police on a round-up of known drug users," the *Post* added. Five people were taken in, but four accounted for their whereabouts that night and were released. The fifth was held for questioning.

Victims of a Secret Society?

Exactly two weeks would pass before the axe murderers would strike again, this time killing an Italian couple in a brutal fight to the death that left behind one of the bloodiest crime scenes of the years-long murder spree. Luigi Vitellaro, forty-two, and his wife, Josephine, thirty-two, met their horrific end at Vitellaro Groceries and Meats, just ten blocks north of where Joseph Klein was cut down.

"Their heads beaten in with an axe, Luigi and Josephine Vitellaro were found in a dying condition at their store at Eighth Ave. N. at 6:30 o'clock this morning," the *Post* reported on January 24, 1923. "Two men came into the store just as the Vitellaroes were preparing to go to bed in a back room of the store. Mrs. Vitellaro had undressed and donned her night robe. [Luigi] Vitellaro went out to see what the men wanted and found them standing in the front of the store, one of them with a bundle under his arm. They asked for sweet potatoes and Vitellaro, securing a bag, stooped over the potato bin. As he did, one of the men struck him with the bundle, which contained an ax."

Luigi fell to the floor. His attacker shifted the axe in his hand, swinging the blunt side of the deadly weapon at Luigi as the gravely wounded man held out his hand in a hopeless effort to save himself. "The ax descended on

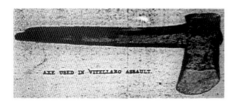

The axe used in the Vitellaro murders. *From the* News, *January 24, 1923.*

his skull and he lay still." Josephine heard the commotion and went to check on her husband. "Written in blood on the floor of the store was the plain story of the tragedy and it was swiftly unraveled by the police under the personal direction of Chief McDuff," the *Post* noted. "She met the bandits about five feet from the front door. One of them attempted to stab her with a knife but only succeeded in cutting her hands. As the two struggled, the other bandit struck her a terrific blow with the blade of the ax. The woman collapsed fatally hurt. Blood spurting from her head formed a big pool on the floor." The house was ransacked before the assailants vanished. The *Post*'s breathless account of the tragedy continued:

> Sometime during the night, Mrs. Vitellaro regained consciousness. Her one idea was to get to a telephone. Despite her terrible wounds, she dragged herself nearly 20 feet down the store and behind a counter in the direction of the telephone. Her exertions started her bleeding afresh and she left a trail of blood marking her path toward the phone. Two feet from the instrument, she collapsed and was found lying there when police entered this morning.

Andrew Hightower, a black man employed at a nearby coal company, saw the couple's bloodied bodies when he went to buy some snuff and ran for help. Luigi survived about a week, although police said he pretended to be asleep when detectives tried to question him. Chief McDuff told the *Post* he believed the men who attacked the Vitellaros were white. "I think this because the man would have been frightened if a negro had come in the store and would have taken precautions he would not have thought necessary with white men," McDuff said.

In her dying moments, Josephine Vitellaro may have confirmed his suspicions. "Mrs. Vitellaro, during a moment of consciousness, nodded her head when asked if white men attacked her, but shook it in the negative when asked if they were negroes." A neighbor of the Vitellaros saw a white man, who looked like the addict questioned in the Klein slaying, lurking near the couple's shop.

If Luigi Vitellaro, for whatever reason, refused to help detectives, police were pleased to report this was one of the first axe cases to offer physical

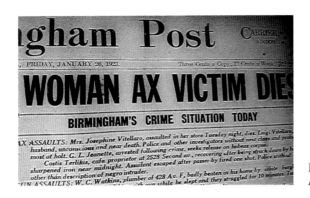

gham Post CARRIER EDITION

FRIDAY, JANUARY 26, 1923. Three Cents a Copy, 12 Cents a Week

WOMAN AX VICTIM DIE

BIRMINGHAM'S CRIME SITUATION TODAY

AX ASSAULTS: Mrs. Josephine Vitellaro, assaulted in her store Tuesday night, dies. Luigi Vitellaro, husband, unconscious and near death. Police and other investigators without new clues and probe most at holt. G. L. Jeanette, arrested following crime, seeks release on habeas corpus. Costis Terlikis, cafe proprietor at 2528 Second av., recovering after being struck down by a sharpened iron near midnight. Assailant escaped after passer-by fired one shot. Police without other than description of negro intruder. W. C. Watkins, plumber of 428 Av. F, badly beaten in his home by white burgl... TIN ASSAULTS: W. C. Watkins, ...n while he slept and they struggled for 10 minutes. Ta...

Luigi Vitellaro neared death.
From the Post, *January 26, 1923.*

evidence—an axe wrapped in bloody newspaper and a bloodied knife. Still, the crime was a mystery for city detectives, deputy sheriffs and a private detective agency that joined the investigation because the couple had been their clients. Police were puzzled why two bulldogs near the backdoor did not bark during the murders and robbery. When strangers entered the next day, the dogs immediately started barking.

"Police also considered the possibility Vitellaro might have quarreled with some people with whom he had dealings regarding buying stolen property." In the store, detectives found cigars they believed may have been stolen. "Vitellaro, according to police records, was convicted in 1920 in federal court of buying, receiving and concealing stolen property and was given 13 months, which he served in the Atlanta penitentiary."

"Another theory advanced, but not given great weight by police, was that the Vitellaros were victims of a secret society levying tributes on foreigners in this district," the *Post* added.

"I Will Shoot to Kill"

Costis Terlikis was working at his small café at 112 Avenue H in the city's west side, two nights after the Vitellaro attacks, when he was attacked and robbed. "Terlikis was struck on the back of the head with a sharp piece of iron, which was found lying on the counter by investigating officers. He was saved from the robbery by the sudden appearance of Jesse Julian," who heard the screams, the *Age-Herald* reported on January 26, 1923. "As the blow fell on his head he screamed at the top of his voice." His cries were heard by a neighbor, Julian, who ran to the shop with his gun.

"Julian stated upon his arrival he fired one shot at a negro who was retreating from the scene, going west on Second Avenue. It is not known if the negro was struck by the bullet." Terlikis was "dazed by the blow, which left an ugly gash in the back of his head." He was taken to Hillman Hospital and recovered.

With the axe attacks refusing to end, Italian grocers lured to Alabama by the promise of a better life were continuing to band together, arming themselves and looking for justice their newfound home failed to provide. Three nights after the Vitellaro murders, grocer C. Fede stopped "what is believed to have been another attempted ax murder" at his shop a few blocks over from the Klein murder scene, according to the *Post*.

It happened around 9:00 p.m., when Fede saw three white men and a black man outside his store. Two of the white men came in as he was closing and demanded change for a five-dollar bill. "Fede told them he didn't have it, and they responded they wanted it anyway." He went to the back and put a gun in his belt. When he returned, they said they wanted a cigar. Fede again said he had no change. They persisted, and he pointed the weapon at them. They left.

Frank Fede—it is not clear if he was related to C. Fede—wrote of the axe murders and a growing fear of organized crime in 1920s Birmingham in his 1994 book, *Italians in the Deep South*.

"The evidence was never clearly linked to the Mafia, but it was commonly felt in the Italian community that such criminal threats were present," Fede wrote. "Italians of Birmingham, especially from Sicily, constantly resisted any attempts at extortion or blackmail. They bent over backwards to thwart such attempts wherever they might appear." Fede interviewed Frances Lucia Oddo, whose father brought her family to Birmingham in 1912 from the Sicilian town of Bisacquino—a region from which the city drew much of its immigrant population at the time. In 1917, her family opened a store, where her aunt and uncle were later assaulted and robbed.

"I don't know if it was the Mafia or what, that was a long time ago. I don't think Birmingham was big enough—there was not enough money here for the Mafia. That was for the big cities," Oddo told Fede.

"A FIEND WHO MURDERS FOR BLOODSHED AND CRUELTY"

May–June 1923

Charley Graffeo is buried in the weed-infested Fraternal Cemetery in west Birmingham's Pratt City neighborhood, his grave shaded beneath trees snapped by the deadly and historic April 27, 2011 tornado outbreak. His mortal remains rest forever beside his bride, Rosina, who died nine months before him, on August 5, 1922, days before she was to turn twenty-seven, leaving him to raise their son, Johnny, and tend the grocery store where he would soon lose his life.

The widowed father was murdered one week after his thirty-ninth birthday. Police believed Graffeo was the victim of a "blackmailer's band" whose "murder resulted from his fellow countrymen knowing his court record as a bootlegger," the *News* reported on May 29, 1923.

Police said Graffeo refused to pay for their silence, and his bloody fate was sealed once the blackmailers learned he was known to carry $400 to $500 on his person, the *News* added. Sometime around 9:30 p.m., Graffeo's body was found by two black men wanting to make a purchase at his downtown shop at 1500 Seventh Avenue North.

"A blood-splattered axe stood behind the door. Its handle was shortened so that it could be carried beneath the coat, police believe," the Associated Press reported in an article that made the front page in cities as far away as Seattle the day after the murder. "The dead man's pockets had been robbed and the store rifled for valuables, investigators found."

About two hours before Graffeo's body was found, Pearl Keyes, who lived with her mother, Mrs. Joe Floyd, in rooms adjoining the store, took Johnny

Left: Charley Graffeo. *From the* News, *May 1923.*

Right: The graves of Rosina and Charley Graffeo. *Author photo.*

Graffeo to the movies. It isn't clear what they saw, but Birmingham's movie offerings that night included Mary Pickford in *Daddy Long-Legs* at the Rialto, *Hunting Big Game in Africa with Gun and Camera* at the Galax and Sinclair Lewis's *Main Street* at the Strand.

Minutes before they returned home, Johnny's father was found face down with his coat over his head. "A small bottle with a funnel in it was found on an oil tank nearby, and Graffeo had apparently been struck down as he prepared to fill the bottle with oil." On the counter was a nickel, possibly used to buy the oil. "The sleeping room at the end was in the wildest disorder."

The two black men who found the body ran from the scene without giving their names, perhaps fearful police would blame them, but alerted two white people they saw on the street. "Detectives who reconstructed the crime today, in an effort to shed some light on the assailants, declared it was one of the most brutal of the whole series of ax assaults which has long shocked the city," the *Post* noted.

While his back was turned, Graffeo was struck seven times on the side of the head. While he was bleeding on the floor, his throat was cut, which was unnecessary. "Any one of the blows on the head would probably have proven fatal. Each of the blows had fractured the skull," the *Post* reported. The weapon was a "typical woodsmen's ax" wrapped in newspaper, with bloody fingerprints too badly smeared to be any good. Police told the *Post* that the

brutal crime was likely the work of a lone assailant. Louis Graffeo said his brother often made the mistake of flashing his cash around.

Detectives believed the killer was left-handed, as Graffeo, with his back turned, was struck only on the left side of his head. Although he was likely killed by the first of the seven axe blows, once he was on the floor, a "keen-bladed knife" was pushed into the left side of the man's neck, coming out the right, and then pushed forward, ripping out his throat.

"The killer, apparently to make sure 'dead men tell no tales,' deliberately hacked Graffeo's throat open with a jagged knife after delivering a crushing blow with the axe," the *Age-Herald* reported. The same sort of knife, also called a "switch back knife," was said to have been used in the Vitellaro murders, the *Post* added. Mrs. Floyd reportedly slept through the whole thing.

Johnny was taken to his uncle's house in Pratt City. Despite "meager clues," there would be a "relentless search," police assured the *Post*. "It may have been solely spur of the moment by a negro or it may have been done by someone wishing to be paid to 'keep quiet.'"

A funeral was held at his uncle Vito's days later, and the orphaned boy lived there for a time before going to live with his aunt Doratea in Illinois.

Charley Graffeo's tombstone. *Author photo.*

Vito, one of ten siblings, including his murdered brother, opened his first grocery store in Birmingham in 1906, and his recipes are today used by the third generation operating the Graffeo Brothers Italian Sausage Company. "Vito took [Johnny] in, but how long he stayed there, I don't know. He wound up in Cicero and opened a bar," Michael Graffeo said in an interview in his downtown Birmingham office.

Fifty-three years after his great-uncle was murdered, Michael Graffeo was delivering mail one final time in the Birmingham suburb of Homewood. Although it baffled his mother and his namesake grandfather, the brother of Charley and Vito Graffeo, the younger Michael was going to start law school in just two weeks. His mother worried about him leaving the security of a civil service job; his grandfather joked he would become a big shot.

Michael Graffeo drove to Illinois just before starting law school to attend a family gathering and briefly met his cousin Johnny. Like the scant details he heard of the murder as a child, he has little memory of this 1976 meeting with the son orphaned by the axeman but looks back proudly on what his forefathers sacrificed to give future generations a better life. At the turn of the century, Graffeo's paternal grandfather, Michele Graffeo, came through New Orleans from Sicily.

"I don't really remember the circumstances of hearing him talk about [the murder] and I always wanted to learn more about it," Graffeo said. "I remember asking him about it and him saying he didn't want to talk about it. Looking back on it, he lost a brother. It makes sense him not wanting to talk about it."

Graffeo's maternal grandfather, Antonino Zito, came to America through Ellis Island, worked at TCI—later known as U.S. Steel—and helped all his children buy their own homes. More than a century after his family toiled and sacrificed to make Birmingham home, Graffeo's relatives are lawyers, doctors, pharmacists and business owners. He suspects his grandfather, the brother of poor, doomed Charley Graffeo, knew the hard-fought good fortune that lay ahead when he decided to cast his lot in America.

"Bisacquino was a wonderful place, but it was a rocky, barren terrain and because so many people from there were ending up in Birmingham, word spread in the village, 'Your brother is there. Your uncle is there. You can get a job sweeping up in his shop until you find something better.'"

In 1987, Michael Graffeo was elected to the Birmingham City Council. Twenty-five years later, he was unopposed as he won a second term as a Jefferson County Circuit Judge. "My family took pride in being here. I inherited all of the family photos. They always looked prosperous," Judge

Graffeo said as people shuffled through the courthouse doors two floors below his office. "That's why they came here. Now, I'm sitting here a judge."

While many immigrants may have dreamed of such success for their children and grandchildren, they faced widespread discrimination and a threat of violence that did not seem to be ending.

"A Period of Delirium"

"Is Birmingham's axeman a white man? Does he alternate with a negro partner, and do they make their getaway in an automobile immediately after slaying their victims?" the *News* asked on June 3, 1923. Mrs. Joe Lantanester was working alone, about 8:30 the night before, while her husband, a former warden of the county jail, was sick in bed. A white man entered the couple's Pearson Avenue shop in West End, asking for change for a $10 bill. She had $160 in her apron but was suspicious and told him she did not have the money.

"The stranger left the store but returned a few minutes later. This time he ordered a small quantity of groceries. While she was filling his order, something fell from his coat and struck the floor with a loud bang," the *News* reported. When she saw the short-handled axe on the floor, the man ran, joined a black man at the front of the store and jumped into a car. It was the same night as the Graffeo murder.

Police, eager to make arrests, began to draw links between the cases, saying they believed many were committed by two men; one went in first, bought something and looked for the light switch. The second man came in and made a purchase while the first man re-entered and turned out the lights. In the Klein, Vitellaro and Graffeo murders, the lights were extinguished, the *News* noted. A Ford was seen near the Klein murder site and later Mrs. Joe Lantanester's store.

"A number of cases bear evidence of having been committed by drug addicts in a period of delirium in order to get more money to buy narcotics," a wire report in the *Messenger and Intelligencer* of Wadesboro, North Carolina, stated on June 7, 1923. Two days after the Graffeo murder, the *News* reported three black men were "being grilled" in the slaying. Arthur Taylor, Earnest Ward and David Wimbush were held as dangerous and suspicious characters. The men "were alleged to have spent large sums of money during the last two days and were unable to give a satisfactory account of themselves," the

Age-Herald reported. Ward was said to possibly be a fugitive on the run from a twenty-two-year Montgomery prison sentence for murder.

They were all soon released, the same day eight Birmingham shops announced they would begin closing at 6:00 p.m. on Saturdays, something the Woman's Christian Temperance Union had lobbied for in the wake of increasing violence. Women were encouraged to shop at those stores abundantly, earlier in the day, as a way of saying thanks.

"The Monster Is Still at Large!"

"Birmingham's Eerie Series of Ax Murder Mysteries" took up a full page of the Sunday, June 17, 1923 edition of the *St. Louis Post-Dispatch*. A special correspondent's report began with a rambling reference to Thomas De Quincey's 1827 essay "On Murder Considered as One of the Fine Arts," arguing Birmingham's "atrocious series of ax murders" would cast history's most infamous murderers as "mere dilettantes." The writer viewed Birmingham's axe murderer as an artist and each new assault and murder his latest unveiling. "The Birmingham axman, according to theorists of that city, made his professional debut on Christmas Eve, 1919, and celebrated his most recent appearance on May 29 last."

The lurid details of the agonizing final moments of immigrants who wanted nothing more than the promise of a better life they believed Birmingham could give their families was easy fodder for writers in a sensational period of American journalism. Although five hundred miles from Birmingham, the *St. Louis Post-Dispatch* wouldn't let pass an opportunity to sell papers that the gruesome Alabama axe murders offered.

"The thought which lowers over this city of 180,000 like a sinister shadow is that the monster is still at large, his identity is utterly unsuspected; that given any moment, walking unmarked and honored among his neighbors, he may be revolving the subject, the time, place and method of his twentieth butchery!"

It was perhaps, however, the chaos that followed the axe murders, as much as the slayings themselves, that attracted the attention of Missouri journalists. Like its southern counterparts, the *Post-Dispatch* could not resist speculating about the origins of the ghastly killers.

"There have been various theories as to the origins of these crimes, such as a bootleggers war, a vendetta imported from abroad, the operations of a

A full-page article in the Sunday, June 17, 1923 edition of the *St. Louis Post-Dispatch* showed Birmingham under the shadow of the axe. *From the* St. Louis Dispatch.

band of murderous drug addicts, quarrels among bands of thieves, or the vengeance of negroes for supposed wrongs against their race."

"Other peculiarities, or perhaps mere coincidences, are that three murders and three attempted murders occurred on the date of Jan. 10 and Jan. 25 in different years, as if these days were red-lettered for some reason on the assassin's calendar." Those cases included the murders of Clem and Alma Crawford in January 1922 and the January 1923 murders of John Robert Turner, Lilly Bell, Joseph Klein and Luigi and Josephine Vitellaro.

But the grand distinguishing feature in several of the crimes has been the gratuitous atrocity....These facts lead Birmingham to believe that a criminal sadist is abroad—a fiend who murders not only for murder but for delight in bloodshed and cruelty; a demon in the last stages of that pathological malady which is observed in its mildest form, in children who are obsessed with a joy in torturing insects and animals, and later as those adults who seek employment as killers in slaughter-houses where they can gratify their passion for witnessing and inflicting death.

The "criminal sadist" would return with his "latest unveiling" in a little more than four months, with one of the most tragic and gruesome double murders in Birmingham history.

"THE MOST TERRIBLE CRIMINALS TO EVER CONFRONT POLICE"

October–November 1923

urry up Ben! Call somebody! Help!" Twenty-six-year-old Juliet Vigilante cried out as she lay in a puddle of her own blood. The young mother had been repeatedly struck in the head with an axe and her throat slashed. Bernard Vigilante heard the cries from his wife and baby as he made his way home from the Jefferson Theatre, where he had just watched Channing Pollock's play *The Fool*.

Like many, Juliet Vigilante's family came to Birmingham from Sicily seeking a better life, but on October 22, 1923, Bernard Vigilante found his American dream butchered. "I came home and saw the lights on and heard my baby crying. I was afraid something was wrong," Vigilante told the *Post*. Juliet "was hit with several terrible blows, fracturing her skull," the *Age-Herald* reported. Thinking she was dead, the killer emptied a register and grabbed a meat cleaver from the back of the store before finding Juliet's mother, sixty-five-year-old widow Elizabeth Romeo, asleep on a bed with the Vigilantes' three-year-old daughter, Caroline.

Bernard Vigilante found the child unharmed and crying in the bed beside her grandmother's lifeless body. The immigrant widow's head was caved in after multiple blows with the cleaver. The killer, the *News* reported, ordered grapes and oranges and then cigarettes, requiring Juliet to turn her back. The "customer" then hit her from behind and she fell, face-down, in front of the cigar counter. "The assassin pulled out a pocket-knife and slit her throat. A large pool of blood back of the counter was still visible Tuesday morning where Mrs. Vigilant [*sic*] had lain for some time."

Left: Elizabeth Romeo and Bernard and Juliet Vigilante with daughter Caroline. *From the* Post, *October 23, 1923.*

Below: Juliet Vigilante's grave. *Author photo.*

How did she scream with her throat cut? Either reports of her crying out were exaggerated or the killers' knife didn't go deep enough to stop the young woman from calling for her husband.

Fifty to sixty dollars were taken from the register and the lights left burning in the store, but not in Romeo's bedroom. "Mrs. Vigilant [*sic*] partially regained consciousness after she had been abandoned in the grocery and stumbled into her mother's room, where she was found by Mr. Vigilante at 11:15 o'clock." He unlocked the door and heard groaning in the dark. Police found bloody fingerprints on the lamp the murderer turned off in the bedroom. "I ran into the room and struck a match," Vigilante told the *Post*. "My wife was on the floor, near the bed. Mrs. Romeo was in the bed bleeding profusely from the wound she had received, and Caroline was

sitting up in the bed crying." Vigilante said his wife, her skull fractured and bleeding badly, mumbled something about a "tall black negro."

"Police believe that Mrs. Romeo was asleep at the time and was never aware of the presence of the slayer. She was struck a powerful blow from which she never regained consciousness," the *Post* report continued. The entire house had been ransacked. "In the center of the room was found a pile of jewelry, valued at $500, which was left behind by the slayer."

"Police believe the axeman was searching for money alone, as nothing else was reported missing." Juliet left "a trail of blood showing her course between the store and bedroom." The *Age-Herald* reported the next day that Jim Taylor, a black man, was jailed at 1:00 a.m. Taylor admitted buying a sandwich at the store but said he had no knowledge of the murders. A pistol was found under his pillow, which was considered incriminating, even though there was no evidence a gun was used in the murders in any way. It is not clear what happened to Taylor.

Juliet Vigilante died at 4:00 a.m. Her relatives offered a $1,000 reward— nearly $15,000 today—for information leading to an arrest, which police said they would not accept even if they caught her murderer without the public's help, the *Age-Herald* reported. Despite the arrest, the crime would soon be considered unsolved once again.

It was a tragic end for Elizabeth Romeo, who left Naples in the 1890s with her husband, Francesco, a railroad worker with whom she raised six children. Her brutal end reunited her with her husband, who had died only

The grave of Elizabeth Romeo. *Author photo.*

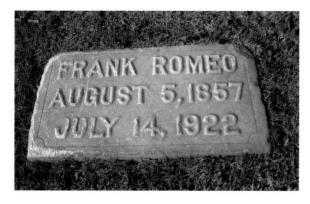

Left: The grave of Frank Romeo. *Author photo*.

Below: This marker in Elmwood Cemetery stands near the graves of Elizabeth Romeo and Juliet Vigilante. *Author photo*.

fifteen months before the gruesome murders. Caroline, according to family history, was adopted by her aunt and grew up to become a nurse.

Frank J. Fede, in *Italians in the Deep South*, described Elizabeth Romeo as a "pioneer" who died "tragically in the presence" of her daughter. The *Birmingham Post* later reported Elizabeth Romeo left behind an estate valued at $20,000—nearly $300,000 today—with her will dividing the money equally between her children and including a "provision disinheriting any who contest the will." Her nephew, Frank J. Romeo, later wrote a column for the *News* called "With the Italians."

"Frank Romeo's articles mentioned Italian happenings all over town in the style of Walter Winchell," Fede wrote. "Few of the social articles in the Birmingham newspapers focused on criminal or unpleasant events, and none buttressed the city's reputation as a murder capital."

The spot where the Vigilante-Romeo store was located is now a vacant lot soon to house a mix of apartments and shops. *Author photo.*

At the time of this writing, the spot where the Vigilante/Romeo Southside home and business once stood is a vacant lot, soon to be occupied by apartments and shops as part of a development anchored by a recently built Publix, the much-larger descendant of the small Italian grocers of the 1920s. This development is welcomed as part of a long-awaited resurgence of a neighborhood that was for many years the hub of Birmingham's night life and a home to many young professionals.

"THE COLORED K.K.K. WILL GET YOU NEXT"

As the axe killer continued to terrorize immigrant merchants in their shops, white men and African American women were still being preyed upon in alleyways. While the predators attacking shopkeepers left no clue to their identities, someone in October 1923 took credit for those "alley murders," the attacks on Turner and Bell and other interracial couples.

A letter purportedly from the "Colored K.K.K." published by the *Post* on October 9, 1923, stated the newspaper should tell "white men to stay out of negro women's houses and go to white women where they belong and won't hear any more murders of white men in negro women's houses." Two young black women who lived near the Turner-Bell crime scene received threatening notes, the *Post* reported. The women reported to police that they had received warnings to keep white men out of their houses or "they would get the same as Lilly Bell."

"When questioned by homicide detectives, they refused to tell how they received the warning. They are quoted as saying 'they were much too afraid to tell.'" A day later, the *Post* shared an anonymous letter given to Detectives Mosser and Elledge by a black woman.

We will get you next—Look out.
COLORED K.K.K.
Ax Men
This means you.

Police agreed such threats could be avoided if no one crossed "the line" separating the races. The line was a societal code, enforceable by flogging and lynching, which kept men—white and black—from turning their eyes toward women of the opposite race. Police, it seemed, believed vigilante justice was an understandable reaction to white men coupling with black women, an unforgivable sin in the 1920s South. "I cannot help feeling the one who crosses the line deserves the resentment of those infringed upon," Chief McDuff said. "The motive behind the crimes is obvious, when you stop to remember that in several instances resentment against miscegenation was quite evident," Sheriff Shirley would later say of the axe murders.

One of America's foremost civil rights leaders of the day, Marcus Garvey, addressed an audience of five hundred people at Sixth Avenue Baptist Church, one of the city's most historic churches, three weeks after the letters appeared. Formed in 1881, the church was a center of civil rights activity in 1963. The church's seventh pastor, the Reverend John Porter, is immortalized in a limestone statue, forever kneeling in prayer in Kelly Ingram Park alongside the Reverend A.D. King—brother of Martin Luther King Jr.—and Reverend Nelson "Fireball" Smith.

On October 30, 1923, Garvey, released on bail six weeks earlier after a federal mail fraud conviction, gave a one-hundred-minute speech, according to the *Reporter*. He repeated his call for blacks to form their own

government in Africa. It was a call that had attracted to Garvey millions of followers, many critics and many adversaries in government, including a young J. Edgar Hoover. Garvey announced:

> *I come to bring you a message of the new Negro, to tell you of the purpose of the Universal Negro Improvement Association with a membership of six million Negro people which has for its purpose the uniting of four hundred million Negro people of the world into one organization looking to the redemption of Africa and the building there of a government for Negroes.*

The speech came at a decisive time for Birmingham, white and black alike. The city would soon implement zoning and segregation laws that would create a barrier between the races and set Birmingham on a course for decades of violence, segregation and shame. Garvey's message was perhaps appealing to some, maybe many, members of the city's large African American population who wanted better futures for their families and did not want to rely on the white man to make that happen:

> *You couldn't think that after the struggles of the Pilgrim Fathers in establishing this Government of the United States, many who fought and died for its independence, they will hand it over to the Negro to be President, governors, and congressmen, and what nots. The Negro must work and fight and die for the building of something he can call his own—a government.… Some of us have been thrifty enough to save money, to dress well and build comfortable homes, we have education and culture. But the man who is not able to protect his home and family hasn't made any progress. Nothing we have here is ours if someone else wants it.*

Though Garvey's speech did not advocate violence, it was believed that some members of the black community were ready to spill the blood of white men and black women they caught together.

Less than a week after Garvey's visit, on November 4, 1923, an elderly man driving a coal wagon through a downtown alley on a Sunday evening made a horrifying discovery—a white man and a black woman clinging to life after a savage attack, according to the *Reporter*. Lena Jackson, fifty, black, was killed, and W.T. Conway, thirty, white, was badly injured with an axe or hatchet. Police theorized at the time that a "negro secret society" was acting violently "to prevent intimate relations of colored women with white men," reports of the crime stated.

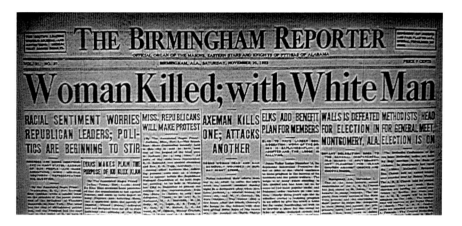

On November 10, 1923, the *Birmingham Reporter* told of the attack on Lena Jackson, fifty, black, and W.T. Conway, thirty, white. *From the* Birmingham Reporter.

Whether such an organization actually existed might be forever a mystery, but it seemed a commonly held belief in 1920s Birmingham, by blacks and whites alike, that such a group was operating in the city, leaving men and women badly wounded or dead.

Jackson died a few hours after the attack at Hillman Hospital, around 10:30 p.m. on Sunday, without regaining consciousness, the *Reporter* stated, while Conway, who lived on Thirty-Fourth Street North between Tenth and Eleventh Avenues, survived with not even the money taken from his pockets. They were found a few feet from a home at 2602 Second Alley North on Sunday at 6:45 p.m. Both were in puddles of blood, their clothes in disarray, their skulls fractured.

Police believed Conway was the first victim, "as he received one powerful blow on the back of the head which fractured his skull….The slayer then attacked the woman, striking her three blows on the back of the head and two on the left side, just above the ear. Her skull was literally crushed from the murderous assault," the *Reporter* noted.

Detective Brannon told reporters the killer took the weapon and left no clues. "The instrument, it is believed, was a heavy weapon which had a sharp hook or spike as the victims bore deep gashes in their heads."

The attacks occurred between 6:30 and 7:00 p.m., and when police arrived, they found that "the blood flowing from the [victims'] wounds was partly congealed."

This case, like the Joseph Klein murder in January 1923, was linked to the use of illegal drugs.

"Conway is believed to have been under the influence of paregoric at the time of the assaults as a phial half filled with that drug was found in his pocket." Paregorics were mixtures containing small amounts of opium that were developed to circumvent federal laws restricting opiates.

The *Reporter* used the opportunity to repeat its fervently held opinion, clearly shared by the city's white lawmen, that such crimes could be avoided. "There must be a stricter adherence to the color line, especially as it regards the social intermingling of the races in Birmingham. This is right, a well-established principle and all races would do well to obey the law and the rule," admonished an editorial likely written by Oscar Adams, a minister who published the weekly newspaper for the city's black community from 1906 until 1934. In 1980, his son Oscar Adams Jr. became the first African American appointed to the Alabama Supreme Court and then the first African American to win a statewide office when he was elected for a full term in 1982.

The writer agreed that a vigilante organization was working to stop racial intermingling and expressed a twisted appreciation for its work.

> *A mysterious murder happened Sunday night in one of our downtown alleys where a Negro woman was killed and a white man was so badly wounded that he is not expected to live. They were found in a compromising position, indicating illicit and unlawful association, and the best survey of all the circumstances goes to show that the disturbing or attacking party was on a mission to stop white men from using unlawfully Negro women....While we do not endorse wholly nor in part the practice we all must confess that as crude as it is, it's medicine that will cure and will have the proper effect on other criminals. Our women should be let alone, the honorable ones should be protected at the expense of life and limb, the dishonest ones should be punished along with their corrupt dealers.*

It's very possible the women were "corrupt dealers" themselves, selling their bodies, the bodies of other women, bootleg liquor or drugs. Whatever it took to escape abject poverty. The reason they were together didn't seem to matter much to those who saw an impenetrable barrier keeping whites and blacks apart. If black women were turning to white men for money on city streets, many of their own race, it appeared, believed they and the white men they were caught with deserved to die.

That day's *Reporter* also carried a column from William Pickens, NAACP field secretary, Talladega College graduate and contributing editor for the

Associated Negro Press, whose words appeared in more than one hundred newspapers nationwide. On the same November 10, 1923 editorial page, Pickens wrote of the KKK in Ohio forming what he described as a black auxiliary of the Klan, although it did not give any specifics as to how the group would operate or if it was at all like Birmingham's so-called "Colored K.K.K." Pickens, however, had his own tongue-in-cheek theory:

> *What place can the Black Kluxers serve in the Invisible Empire? Simple enough: the white Kluxers will need dishwashers and waiters and chauffeurs, and also there must be doorkeepers at the "klaverns." The tar will have to be boiled and stirred right and poured up into convenient tins, and who could work better in tar than black Kluxers?*

"A Skull with a Patch of Silver"

"The police are helpless—they have been trained to detect criminals but know nothing about hunting down a fiend. They do not know how to go about it," the *New Castle News* in Pennsylvania claimed in a full-page article on November 21, 1923. "A man of ordinary nerve would be excited by his crime—the axman apparently never is. He seems to be able to saunter forth—to mingle with the crowds—to live with other people without ever being suspected. Insanity has raised his cunning—his peerless cunning to genius."

Merchants had begun donning helmets from the Great War near closing time to protect their heads if the axeman visited, the article stated. An editorial months earlier in the *News* had advised shopkeepers to take that very step. "German helmets are said to be more in evidence than American or French ones, mainly because the German is built of a better design and covers the neck better, thus giving better protection to an attack from behind," the article continued.

"A great number of these tin hats have been shipped into Birmingham from an army and navy goods store in Atlanta." If that is true, there are no reports of the helmets being worn by any of the victims. The unnamed author of the report shared the thoughts of an unnamed merchant who he said wore just such a helmet, along with his white apron. "I was in France and saw several months in the trenches, but I tell you the truth when I say I feel in greater danger here than I did there."

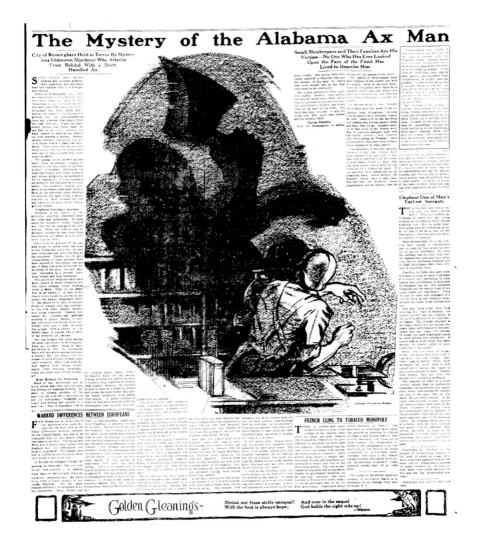

A full page of the *New Castle News* in Pennsylvania was devoted to the murders on November 21, 1923. *From the* New Castle News.

"The police in Birmingham have been diligent in the matter, but with no results," the piece went on. "It is believed the man is sane to all appearances and that his natural cunning and wit are just as great—much greater than the ordinary man in some phases. All in all, he is one of the most terrible criminals that has ever confronted the police of any city."

Three days after the *New Castle News* wrote of Birmingham's "most terrible criminals," John Juliana sat up in his hospital bed and, to the amazement of

all around him, lit up a cigar. Only twelve hours earlier Juliana had survived a rare, life-saving surgery that replaced a fractured piece of his skull with a silver plate.

Juliana came from the Tuscaloosa County coal town of Searles, where he worked as a miner and lived with his wife and young daughter, to visit his many Italian friends, just hours before he was assaulted and sent to the surgery table, according to news reports.

"Friends stated that the reason for the injured man's appearance in Birmingham Saturday was due to the fact that he had been sick for some time and he had come here to solicit funds from his friends. One of them stated it had been planned that a collection would be taken up Monday among foreigners of Birmingham for Juliana's benefit," the *News* reported on November 25, 1923—the day after Juliana nearly died on a dark city street.

"Only one time since he became a citizen of America has Juliana been in any trouble, according to friends, this being a short time ago when he was arrested and placed under bond, charged with shooting a miner. He was at liberty under bond when attacked….It is believed he was trailed through many sections of Birmingham Saturday by his assailant, who knew he carried a large sum of money on his person," the *News* reported.

While he was visiting a friend's store, a "tall negro of a suspicious appearance" twice entered the shop. The first time, he bought a five-cent bar of soap, but the second time he only looked around. The black man, the report stated, kept looking at Juliana and left the store for a second time, not long before the attack. "Immediately after hearing of the attack, numbers of Italians and Greeks throughout the city loaded and placed close to their hands their guns, stating they would be in readiness at all times to shoot any suspicious character, who refused to give reason for entering their establishment."

After his miraculous recovery, police hoped Juliana would be able to identify his attacker, but he only recalled hearing someone walking up behind him on Eighth Avenue North between Twenty-Fifth and Twenty-Sixth Streets. "Suddenly, he stated, someone struck him and, within two minutes had robbed him of about $100 and a gold watch," the *News* later reported. The only likely weapon police found at the scene was a piece of brick, which they checked for fingerprints. "The fiend" also took valuable papers from Juliana, which were later found on the sidewalk.

A man identified only as G. Todd, who lived at 2911 Eighth Avenue North, heard a scream, ran to see what was going on and found Juliana.

Tennessee Coal, Iron and Railroad Company furnaces in Ensley, circa 1910–20. *Library of Congress.*

"He struck me with a bottle," Juliana murmured. Police, however, believed a hammer was used. "It was revealed Juliana's cap bore a hole about the size of a hammer." Juliana rambled about a car, which his friends could not explain, leading police to believe the attacker had a getaway vehicle.

"It was considered only a matter of time until death would claim him. The arteries and veins in his forehead were ruptured and had to be sewn. The patient suffered from the violent shock and hemorrhages all night," the *Age-Herald* reported on November 26, 1923. "At 10 o'clock Sunday morning, the 'hammerman' victim showed a slight improvement and scientific effort to restore his life renewed." As Juliana clung to life, police said the "skillful work" of Birmingham General Hospital's doctors might end the axe murders—assuming he survived the operation and was left with any memory. The renewed effort paid off, even if it did not lead to an arrest.

"Sitting up in bed and smoking a cigar 12 hours after the back of his head had been smashed in with a sledge hammer, was the status of health of John Juliana, whose skull had been patched with a plate of silver a few

hours after what was thought to be the body of a dead man had been brought to the Birmingham General Hospital." The next day, he was sitting up and eating, and although he was said to be in little pain, Juliana had little information to offer.

"Juliana has a round hole the size of the base of a ten-pound hammer in the back of the head. The bone was completely broken and was resting on the brain," the *Age-Herald* added, identifying Drs. W.A. Davidson and L.J. Johns as the surgeons who performed the operation. The surgeons "removed the splintered parts and replaced parts of the skull with a silver shield." Despite the success of the surgery, Juliana either never saw his assailant or was not able to recall enough to help the investigators. However, his recovery was miraculous:

> *The operation performed on Juliana is one of the most delicate in surgery, it is stated, and is only tried by skilled doctors. Special nurses have been appointed to watch the patient day and night, and every scientific effort is being made to make the operation a success.... The operation the Italian underwent has been performed successfully in other instances in some of the larger cities, but not always with success and, it is believed, successfully for the first time in Birmingham. Until a few years ago, it was believed impossible.*

"THERE IS NO MONSTER IN BIRMINGHAM"

December 1923

His wife languishing in the hospital, Edwin Sparks paced his jail cell, crying out he was innocent of fracturing the twenty-six-year-old's skull. "According to Sparks account to the deputies," the *Age-Herald* reported after the December 9, 1923 assaults, "he and his wife were walking along the street when two negroes jumped out of the alley flourishing guns."

Sparks claimed that one of the men held a gun on him while his accomplice restrained Sparks by tying his hands behind his back with a handkerchief. The pair robbed him and then struck his wife in the head before dragging her twenty feet down the alley. A group of deputies passing by minutes later, "hearing her screams," got out of their car and found her in a pool of blood. Police, however, had a different idea about how Mrs. Sparks ended up in the hospital, telling reporters they believed her husband hit her with a brick. "They stated that a brick with fresh blood stains and chipped edges was found at the scene of the attack. In the alley where the couple were found, the officers picked up a half pint bottle of liquor which was splattered with blood. No sign of binding material was found in the vicinity, they said."

"Mrs. Sparks, before going to sleep, was calling constantly for her husband and begging him to not let the negroes hit her anymore. A piece of the skull was removed by the surgeons." The couple had been married about three months and lived at the Phoenix Hotel, said neighbors Mr. and Mrs. Taylor. The wife, whose first name was never reported, had a nine-year-old daughter, Louise Mack, from a previous marriage; Edwin Sparks was an unemployed electrician. Deputies grilled him for more than two hours

Sunday night before charging him with assault with intent to kill. By then, Mrs. Sparks was improving, backed his story and said it was two black men who robbed her husband and hit her. Edwin was freed from jail.

Mrs. Sparks had not only freed her husband from jail, but she had also given police a valuable weapon in their fight against the axeman. Her identification of the assailant was the thread that would soon help unravel the years-long mystery. But the murders were not yet over.

The day after this December 9 assault, a man named J.E. Heywood died from wounds he received on November 29, the United Press reported. "His skull was fractured and he lay all night in freezing cold before he was discovered. Nature of the wound indicated he was hit with a sharpened piece of pipe but the man, who was only occasionally conscious, could tell nothing of the night." His body was to be sent to Heflin, Alabama, for burial, the *Post* noted. "Heywood was a native of Tipton, Ga. and had been living with his sister in Irondale while working for the T.C.I. Comp," the article stated.

The night Heywood died, in a seemingly unrelated appearance, forty white-robed members of the Women of the Ku Klux Klan visited Parker Memorial Church and presented the Reverend Eugene Adams with twenty-five dollars to further "the cause of Christianity," the *Age-Herald* reported. "No demonstration of any kind was made by the hooded and white-robed figures as they filed up the aisles of the church. Mr. Adams asked them to kneel with him in prayer. At the close of his prayer the women filed slowly out and vanished into the night."

"A Woman Is the Right-Hand Man"

Almost four years after the murders began, police announced they believed "the long hunt for Birmingham's ax man" was at an end, the *Age-Herald* reported on December 11, 1923. As she recovered from her assault a few days earlier, Mrs. Sparks identified Fred Glover as the man who set upon her and her husband. She identified Glover by the "lump" over his eye and the gun officers found on him, she said, by the way the light hit its "blue steel" barrel. "The negro was taken to the county jail, where he was placed in a cell, where no one will be allowed to see him, until a further check of his recent actions can be made. With the arrest of Glover, the county officers are prone to believe, in view of the evidence in their possession, they have at last captured the one, if not one of Birmingham's ax murderers."

Glover had been arrested that Monday night and taken to his home, where officers found a bloody hatchet and a pistol, the *News* reported. "To further clinch the evidence against Glover, officers said he was suffering from a severely bruised wrist which was dressed a short time after the attack Sunday evening." How Glover's wrist was bruised was never disclosed, but police seemed to view it as a key piece of evidence.

Police had considered Glover, who had been previously arrested on unrelated charges, a suspect for a while, it seemed, despite his airtight alibi for the first several attacks. A year and a half earlier, he had been sentenced to fourteen months in jail on charges of burglary and grand larceny, but with good behavior, he was released in July 1923. Police would later suggest that Glover had actually been the leader of a group of murderers and had run the axe gang from prison.

Glover, a mechanic for a local oil distributing company, had been arrested about a month prior near the Terminal Station. He was said to have thrown an axe that had been concealed under his coat onto a nearby front porch while he was fleeing from two beat patrolmen. The weapon in question was a short-handled axe, apparently the same kind that had been used in many of the assaults. He was held in jail for two days. While there, a local furniture dealer identified him as the man he had discovered attempting to break into his home. The arrest apparently came as a surprise to his employers, as "he was said to be a faithful worker and to the best of their knowledge a trustworthy negro."

Despite the mounting evidence, Glover was released on bond shortly after his arrest. Police claimed that he'd been released in order to "give him more rope," in the hopes he'd lead them to some ironclad evidence linking him to the axeman crimes.

Glover wasn't the only one arrested in December 1923 in connection with the axeman slayings.

The *News* of December 12, 1923, noted that five arrests had been made in two days in connection to the axe cases. One was suspected of being the assailant of J.E. Heywood of Irondale, the man who had been struck two weeks prior on Third Avenue, near Twenty-Fourth Street, and later died. Two of the men—Will Wright and Herschel Heath—were nabbed in Second Alley, between Twenty-Third and Twenty-Fourth Streets. They were arrested in the company of two drunk white men, and police suspected the pair had been planning to rob them. Heath, believed to have spent time in the penitentiary before, was known as "String Beans," and Wright sometimes went by Will Jones, John Brown, Will Brown and Will

Seals. Wright had previously served five years on a charge of assault with intent to murder.

Glover, meanwhile, was held without bail for assault with intent to murder. Deputy Sheriff Homer Badger, special officer assigned to the axe murder mysteries by Sheriff T.E. Shirley, suspected that Glover was the leader of a gang of five murderers and criminals who had been terrorizing Birmingham for the last two years.

The *News* article claimed Pearl Bailey, a woman among those arrested, and later referred to as Pearl Jackson, was "the right-hand man of the leader.…Deputies believe that with her apprehension, a majority of the axe crimes will be cleared up." Glover, the article stated, was the ringleader.

"The negroes work under (Glover's) orders and a majority of the crimes can be traced to robbery as a motive. 'Dead men tell no tales' seems to have been the slogan of the gang, and its operations have been so successful that the master mind grew a little too bold and came within the clutches of the law," Deputy Sheriff Badger told the *News*.

Glover, meanwhile, continued to protest his innocence. The *News* interviewed Glover in his cell and described him as "indifferent about the charge against him" and reported he "would talk but little, and then only to defend himself with the declaration, 'I'm not the man wanted. Someone else has fooled the law.'"

"He declares that he has been the 'dog' of the law ever since he got into trouble before and that 'Everything that happens they blame on me.'" The *News* noted Glover, who was five feet, nine inches tall and weighed over two hundred pounds, "seems to be better educated than the ordinary negro."

"We are sure we have the right man and think we are going to be able to place the responsibility for the other attacks that have been made right along," Solicitor James Davis told the AP. Despite the police department's confidence, the citizens of Birmingham remained unsure that the right man had been arrested. "So many fruitless arrests have been made in the past that there are many skeptical of Glover's connection with the crimes."

Sheriff Shirley announced that four deputies were assigned to "devote their whole time to clear up the series of ax and hatchet attacks.…[I]t is expected the motive behind these crimes will be revealed," the *Age-Herald* reported on December 15, 1923. "It may take three years, but we are determined to get to the bottom of this thing," commented Chief Deputy Henry Hill. "We are certain we have the right man in custody, but there are other phases to be worked out. We shall not rest until the whole mystery is explained."

An editorial in the black-owned *Reporter* after the arrests decried the "extraordinary effort to scandal the south and the negro" during the course of the crime spree:

> *The axe murders of Birmingham have offered much for discussion and the news writers have imagined more about the situation than exists and dared to put their imaginations into print, which makes a very bad and ugly picture for Birmingham and the Negro people in particular. The Negro is easy prey for officers, not in the South alone, but throughout America, and the crime of the axe murderer has been placed at his door, not because of being a crime traceable to his nature, or one according to his dispositions and habits. It is shifted to the negro because the criminal has not been apprehended and the burden may rest upon his shoulders with less opposition and criticism than it could upon the head and shoulders of any other race group.*

Nineteen-year-old Pearl Jackson; her husband, Odell; and Peyton Johnson were charged with the Turner-Bell murder and assault and taken to the county jail after three days in the city lockup, the *News* reported that same day. They were arrested by Detectives Paul Cole, H.C. Propst and M.E. McDuff. "The trio, according to police, is believed to be members of a gang of five. One of the party is still at large, they say, while the fifth member was slain recently in a brawl.…One of the trio is said to have confessed, implicating all five. The negroes are suspected of other alley assaults in Birmingham."

One of the arresting officers, Milton McDuff, Chief Fred McDuff's son, gave an interview on the case for the Sunday joint edition of the *News* and *Age-Herald* on December 4, 1932, eight years after the arrests, in which he revealed how the police came to find these suspects:

> *Some years ago, a little Negro used to hang around the City Hall a great deal. One day he asked one of the officers for a few dollars to buy himself some clothes. The officer told him no, to get out, to stay out. The Negro came to me and on a hunch I gave him $3. At the time, Birmingham was being terrorized by a gang of ax murderers. All of us were doing everything we could to catch the killers, but we were having no luck at all.*
>
> *Then at 2 a.m. one day this little Negro came to headquarters looking for me. I hurried down from home and heard this story: he had been living in a two-room house and heard a gang of Negroes drinking and boasting about which of them was most dangerous. As they got drunker and drunker*

Birmingham detective Milton McDuff. *From the* News-Age-Herald, *December 4, 1932.*

they told more and more until they began to cite specific cases where they had used the ax.

A few nights later we got the little Negro and sent him into the house where the tough boys lived. They began to drink and after they were well into their liquor, three of us entered the next room and heard them brag about how bad they were, we waited until they mentioned definite cases, then we kicked the door in and made the arrests.

"THE SECRET OF BIRMINGHAM'S BAFFLING AX ATTACKS"

Birmingham's top two lawmen, Sheriff Shirley and Chief McDuff, predicted the "activity of Birmingham's dreaded 'ax man'" was about to end, although both played down the sensational accounts of the crimes and the city's violent reputation, the *Age-Herald* reported on December 17, 1923. Chief McDuff in particular expressed doubt in the idea that there was a singular axeman at work in the city:

There is no monster in Birmingham. I doubt if the same person has figured in any two of the so-called "ax murders." The creature viewed

as one individual is a figment of the imagination. There is nothing mythical about Birmingham's murders; they are just the outcrop of ordinary drab, vice and crime arising from the natural causes, and by no means peculiar to Birmingham. The circumstances in practically every case were brought about by, or partly so, the person murdered. I wouldn't hesitate to say Birmingham is freer from ordinary crime than any city of its size in the country.

Perhaps as a way of calming a frightened population, perhaps just a reflection of his beliefs, the chief announced that many of the victims of these crimes had themselves been engaging in illegal or immoral conduct, which invited the attacks. Murders, McDuff said, often stemmed from miscegenation or fights between thieves and fences—those who made their living illegally buying and selling stolen goods. "Often there is evidence of blackmail. All of it is a direct result of illegal conduct, and to prove it I have only to tell you that in every case that the attacked man, on regaining consciousness, refused to give any information."

Sheriff Thomas Shirley said he, too, believed a mingling of the races—and violent efforts by other African Americans to stop it—was to blame in many of the attacks:

Uncover the operations of a compact group of negro men, secretly organized as vigilantes and the secret of Birmingham's baffling series of violent ax attacks will be laid bare. This band is responsible for the vast majority of the attacks. We have learned this much from negroes now under arrest. And, the motive behind the crimes is obvious, when you stop to remember that in several instances resentment against miscegenation was quite evident.

In some cases, however, police believed the killers were common robbers and not racially motivated vigilantes. Either way, officials believed the criminals would soon face justice, if the public would cooperate. Shirley concluded:

Progress has been made lately and while I cannot talk freely now, I can state that we expect to make arrests in a short time which will include all of the leaders of the organization we believe to be responsible. Negroes recently arrested have provided us with valuable information, and I am entirely confident that ax attacks in Jefferson County will soon be broken up.

Police cooperation is essential especially in view of the ridiculously small number of men on the city's police force. It is a fact that the majority of axe crimes have been committed in places which were not patrolled by police. It would have been an accident if an officer had caught any of the axmen at their work.

As Christmas 1923 neared, and with it the fourth anniversary of the murder of John Belser, said to be the first axe victim, it seemed the work of Birmingham lawmen might finally pay off. It appeared for a moment the citizens of this prosperous young city could perhaps look forward to peace with the start of the new year, but more tragedy awaited Birmingham in 1924.

"A MIDNIGHT VISIT FROM GRIM AND SILENT MEN"

January–February 1924

s the new year dawned, police remained confident that Birmingham's years of terror were behind them. "Four negro leaders of Birmingham's notorious 'ax syndicate' are in jail," the *Age-Herald* announced on January 7, 1924. With the arrests of the four suspects, Fred Glover, Peyton Johnson, Odell and Pearl Jackson, and later a fifth suspect, Ed "Bulls Eye" Jackson, authorities were eager to declare an end to the murderous spree.

"Under relentless grilling of city and county officers, the negroes finally opened up and talked freely of the attacks," Sheriff Shirley told the *Age-Herald*. "Startling declarations will be made public as soon as the grand jury acts, he indicated," the report confirmed.

Although the sheriff admitted to employing "strong mental pressure" to extract these confessions, he was adamant that no torture or physical methods had been used in questioning the witnesses. However, the police department's methods are questionable to modern eyes.

"'We have the leaders in custody and we have a great mass of information concerning nearly all the attacks,' the sheriff continued. 'There is no question about it—we have the situation in hand. You've noticed there have been no attacks in the past two weeks, haven't you?'"

On January 8, 1924, authorities dropped a bombshell: the suspects made their confessions after they were injected with "a truth serum," revealed to be a mixture of scopolamine and morphine.

The drug was originally given to women to ease the pain of childbirth. In 1922, Texas obstetrician Dr. Robert House wrote to the Texas Medical Association that he observed his patients found it "impossible to lie" when given the drug, and he believed it held great potential for police. "If my assertion is correct, there is no justifiable reason for any person to be convicted upon circumstantial evidence, nor any reason for the brutal third degree methods." Through the 1920s, House wrote numerous articles boasting of the drug's ability to solve crimes.

In a front-page jailhouse interview with the *News*, Peyton Johnson described receiving a shot of a "white fluid just below the shoulder" and immediately after becoming dizzy.

After receiving the shot, the police began the interrogation. Johnson and Odell Jackson were asked what color pants they were wearing, what time it was and if they had taken part in the murders. "It's a funny feeling. Feels like you're sleeping, but you are not. Just floating around would be a good description," Jackson said. According to the *Post*, Johnson had been given three shots with a hypodermic needle in his arm. "Odell Jackson was given four injections and Pearl Jackson was given three—which made her 'powerful sick.'" Odell Jackson and Johnson denied that they had ever confessed, despite the sheriff's claim.

Birmingham attorney Roderick Beddow told a reporter he had previously represented a black man, Rufus Anthony, who was also given such an injection while being questioned as a suspect in the Vigilante-Romeo case. At the jail, a man who said he was a doctor told Anthony he was sick and should go to bed, Beddow told the *Post*. Anthony complied, although he did not feel sick.

"The negro then told me he was shot in the arm with a long needle, after which he became sleepy and tired. A number of men came into the room and questioned him and he remembers answering a lot of questions," Beddow said. The lawyer, who would come to be known as Alabama's greatest defense attorney and "the Perry Mason of Birmingham" for his decades of legal victories, told the *Post* that Anthony was released without charges and sued the county for $50,000. (It's unclear how the suit was resolved.) Attorney Frank Smith said a black woman named Alberta Slaughter was released from jail on November 17, 1923, following a liquor arrest after she, too, was injected with a serum, weeks before the axe murder arrests. Slaughter and Anthony were apparently never mentioned again in connection with the axe murders. Although scopolamine injections were used in numerous cases throughout the 1920s, it quickly fell out of favor

with police. A 2012 Vice News documentary featured scopolamine, calling it the "devil's breath" and the "world's most dangerous drug." The U.S. State Department that year advised travelers to Colombia not to accept food or drinks from strangers, as scopolamine was used to rob tourists, effectively turning them into zombies who emptied their bank accounts for the person who slipped them the drug.

According to a 1993 CIA report made public in 2007:

> *Because of a number of undesirable side effects, scopolamine was shortly disqualified as a "truth" drug. Among the most disabling of the side effects are hallucinations, disturbed perception, somnolence, and physiological phenomena such as headache, rapid heart, and blurred vision, which distract the subject from the central purpose of the interview. The fantastically, almost painfully, dry "desert" mouth brought on by the drug is hardly conducive to free talking, even in a tractable subject.*

Rather than inducing people to tell the truth, scopolamine made users highly suggestible. Questioning people under the influence of scopolamine could result in the creation of fabricated memories and false confessions. The U.S. Supreme Court in 1963 ruled use of such truth serums in interrogations was a form of torture. Such protections were a long way off from Birmingham in 1924, however.

"THE GREATEST MYSTERY THAT EVER BAFFLED THE SOUTH"

"A strange new nemesis, mysterious and terrifying, has come to hover about the cells of prisoners in Birmingham. It creeps upon its victim in the lonely hours of midnight; it strikes with little warning, and once it has struck there can be no escape from its grip, no alibis, no lying, no dodging the truth," the *St. Louis Post-Dispatch* reported on January 27, 1924. "There is a twinge of pain as its talons pierce the arm, a reeling sensation of dizziness, a fading into semi-consciousness and the man becomes his own examiner. If there is on his conscience a guilty secret, it finds its way to his lips, and when he wakens he stands cleared or convicted by word of his own mouth."

The article painted a vivid picture of the bizarre scene that played out as police turned to a truth serum to crack the axe murder cases.

The use of a truth serum was described by the *St. Louis Post-Dispatch* in a full-page article on Sunday, January 27, 1924. *From the* St. Louis Post-Dispatch.

Investigators hoped the drug-elicited confessions would "clear up the greatest mystery that ever baffled the South's detectives." Prosecutors were ready to put it to the test when the so-called axe gang stood trial on February 25. "If convictions are obtained, the success will mean scopolamine has revolutionized criminal procedure and put in the hands of the law its most powerful weapon." But before the cases ever reached a courtroom, the drug

was first administered to the unwilling suspects in the dead of a cold winter's night, without a word of explanation to those they summoned from their jail cells and led down a silent and deserted street:

> *Twice, under the veil of utmost secrecy, it has been administered by the county physician and his staff of assistants, and twice, implicating themselves and other negroes, they told the same stories of the killings; of a grim "ax syndicate" of murderers and robbers marking their victims at secret meetings and drawing straws to designate the man who would wield the bludgeon; of their visits to outlying stores after dark; of their murderous attacks and the division of loot.*

The drug-induced midnight confessions quickly grabbed the imaginations of frantic reporters across America who were catching wind of Birmingham's newest "scientific" endeavor in the fight against violent crime. Southern lawmen and doctors waking black prisoners and leading them from their cells to the bewilderment of their jail mates made for the kind of sensational journalism irresistible to some writers.

"It was a setting weird and appalling that attended the advent of scopolamine in the Birmingham city jail—one that will not soon be forgotten by those prisoners who chanced to witness the eerie spectacle. Under no conditions does a midnight visit of four or five grim and silent men to a cell holding a negro suspected of murder inspire courage in Southern jails," the *Post-Dispatch* piece continued.

It's unlikely anyone occupying a Birmingham jail cell that night knew anything of truth serums. The sound of footsteps breaking the silence of the cellblock could not, they probably thought, portend anything good for the men behind bars. Odell Jackson would be the first to find out "when the mysterious group of officers and spectacled doctors walked quietly through the corridors and stopped" at his cell:

> *The negro was aroused from his sleep in bewilderment. Others in nearby cells heard the prisoner's alarmed protests and stirred from their slumber to look aghast at the proceedings. What was it, a lynching? Who could tell? Some of them recognized the sheriff in the group, but what of that? Sheriffs had been known to join lynching parties before in the South. There was no great consolation in his presence....The visitors never said a word to their prisoner or to the horrified spectators. They clanged the door of the empty cell, and with the negro in their custody, departed as they had come.*

Jackson asked the men what they wanted with him but received not a word of reply as they marched him "out into the cold night air...already shivering from fright. There was no mob awaiting him as he half expected to find; there was nobody in sight, in fact, and that made the suspense even more wracking. On they went down a deserted street and into a large office building."

It was a doctor's office. Odell Jackson was stripped to the waist. "His questions were met with the same mysterious silence that had inspired such terror at the jail. What were they going to do with him? He wailed again." He was given one shot in his right arm, one in the left, then the right again. The fluid "looked like corn whiskey," Odell said.

Odell Jackson had no idea what was in the syringe, what it would do to his body and that in that moment, late at night surrounded by police and doctors, he would unknowingly and unwillingly begin to talk, his own involuntary words now threatening to send him and his young wife to their deaths.

"In a moment he began to grow dizzy and 'dead sick.' He reeled and rolled his eyes. As he began to lose consciousness the doctors placed him on a cot and the examination began. Vague questions about murder were fired at him. How did he kill a certain man? What did he do it with? Who helped him?"

As they peppered him with questions, Odell Jackson, woozy from the drugs, denied he "had killed anybody or knew anything about a murder. Then he fell into a stupor and something else began to talk. What was it? Enemies of the drug say it was hypnosis—his responses to suggestions which in such a state he might make, whether guilty or not."

Although police eagerly proclaimed to have secured confessions they said would end the axe murders, the suspects "declare they made no confessions at all. Kept in solitary confinement in closely guarded cells since the examinations, they have had few opportunities to talk, but from time to time, have given piecemeal their versions of the new 'third-degree' inquiry. They remember nothing of the questions asked."

Fred Glover, charged in the assault and robbery of Mr. and Mrs. Edwin Sparks, was said to have been the second injected and the second to confess. Glover denied that, according to the *Post-Dispatch*. Like Odell Jackson, Glover said he was terrified by the experience, having seen Jackson "laid out. I thought he was dead," as he was led to the doctor's office under the cover of night. Glover recounted:

Four men came to my cell and took me to a doctor's office after 2 o'clock one morning.…A doctor that wore glasses took my coat and shirt off and shot me twice in both arms with a syringe and they all began asking me questions. They asked me what time it was and tried to get me to tell about a murder, but I didn't have anything to tell. They asked me if I struck anybody and who was with me. I was dizzy and sick and couldn't talk. The stuff nearly set me crazy. It took me several minutes, it looked like, to say one word, and I never did remember telling them what they said I did. I didn't make no confession and if they said I did they're crazy. If I did make it, I was asleep.

Glover was the second person given the drug and, the report stated, gave "the most coherent story about the strange ordeal." The experience might have been terrifying for the prisoners, but police were quick to champion the use of scopolamine, the so-called truth serum, as "the greatest discovery in the annals of criminal procedure."

"We are going to use it in all our criminal cases after this," Sheriff Tom Shirley added. "These 'truth serum' tests have been too convincing to ignore. I have placed orders for large quantities of the drug, but I'm not going to disclose how I expect to use it until these cases have been disposed of."

But it seemed some involved in the strange interrogations were skeptical as to whether the drugs should be used to question suspects. "The physician who is said to have administered the drug has had less to say about it than the sheriff." The doctor, who went unnamed in this article, said the drug "lifts the brakes, or, in other words, the will power, from the mind and makes the subject tell everything he knows about matters suggested to him. Sometimes it doesn't work, but in that case the subject doesn't talk at all. He never concocts fictitious tales when under its influence. He can't." The doctor wasn't worried about the possibility of an overdose, because "prisoners are always carefully examined before it is injected."

Even in 1924, however, there were concerns that scopolamine was "dangerous and cruel," that its results were wholly unreliable and that it could perhaps even lead to death.

"Besides, [critics] predict that the confessions obtained by means of it will be worthless, when the cases come up for trial, on the ground that they were not given voluntarily." After several people expressed doubt they would get the same confessions under a second round of drugging, a second test was conducted in the daytime, without "the midnight secrecy" of the first experiment.

"Odell Jackson was again the first subject. He was administered several short doses of the drug and questioned as before. After he had come out from under the drug's influence, he remembered nothing of what had passed. He told the same tale of the murders he had taken part in, gave the same number of murders for which the 'ax syndicate' was responsible and explained as before the organization's method of operation. Even his words and expressions were similar."

This time, Pearl Jackson was the second one given the injection. "She corroborated the account given by Odell, and she added several details to the story. Peyton Johnson's confession tallied with the two others and with his previous version. Fred Glover corroborated a number of the facts given by the others, but, as before, seemed to know less than the rest about the actual murders."

"The Truth Comes Trickling Out"

Whatever questions might have been raised by the use of the drug, the idea that a simple injection could end a brutal series of axe murders continued to fascinate newspaper readers across America.

"Science—and chance—have lifted the veil of mystery that has covered Birmingham's long list of ax murders. Birmingham's reign of terror is at end," *Central Press* correspondent J. Fisher Rothermel wrote in a February 2, 1924 wire report. "The band varied in size from eight to ten. Three others are being sought. One of these was the ring leader. Another member of the gang is now dead."

Yet again, the use of the truth serum was fodder for a sensationalistic article that painted a grim picture of the twisted lengths police and prosecutors would go to end the axe murders:

> *The success of the Alabama officials in using the painless third degree will doubtless encourage the police in large cities to try the scopolamine treatment—if they're not using it already. It seems a tidier and more scientific treatment than the pummeling, booting, shouting, contradicting, threatening, postling, terrifying, and browbeating of the old "third degree." Instead of all that blood and violence, a gentlemanly police surgeon gives the prisoner a shot of the official dope and—voila! The truth comes trickling out.*

Axe murder suspects John Reed, Peyton Johnson, Fred Glover, Pearl Jackson and Odell Jackson. *From the* San Bernardino Daily Sun, *January 28, 1924.*

Rothermel, despite the *Post-Dispatch* report, said Glover did confess, attributing to Glover the sort of derogatory dialect often used at the time when southern newspapers quoted African Americans. "When [Glover] awoke, he remembered all he had told and in the presence of witnesses said it all again, big eyed, amazed that he should have told the things that might mean his death, awed by the science that made him do it...."Fore God,

Cap'n,' he said. 'If I'd knowed ders was such stuff to make a poor nigger tell da truth, I'd nevah done all dat.'"

Once again, police and prosecutors in Birmingham seemed eager to grab the attention of national journalists and extoll what they said were near miraculous benefits from the truth serum. It might be cruel, it might be deadly and the confessions might not stand up in court, but police nonetheless credited the injections with stopping the spread of violence in the city:

> *Crime has noticeably decreased in Birmingham since it became known among the negroes that the white folks had something which could make you tell all you had done. While the officers and doctors are somewhat at odds, Birmingham as a whole and especially the small shopkeepers in the outlying and negro sections are believing that the "ax murders" are over. What the juries will think of the confessions and the truth drug will constitute a pretty big fight later on.*

That fight was about to begin.

"Glover took the stand in his own defense when court opened Friday morning, and after denying any connection with the attack on Mrs. Sparks, was asked by his attorney whether or not he was subjected by state officials to an injection of the fluid," the *News* reported on February 8, 1924. Prosecutors objected, saying they had presented no evidence related to the drug and the questioning was irrelevant. The judge agreed. Glover was convicted of robbery and assault with intent to kill after an hour's deliberation by the jury. He was taken back to a cell to await sentencing.

"The most sensational testimony brought out during the hearing was when Mr. and Mrs. Sparks both testified that the negro asked Mrs. Sparks to 'kiss him' and when she refused to do so, he threatened that she would be 'plenty willing to do so before he was through with her.' It was brought out that when the negro turned his head at an exclamation of the woman, she grabbed his gun, and that later Glover became frightened and left," the *News* reported the next day.

As trials were to begin for Peyton Johnson and the Jacksons, prosecutors now acknowledged the confessions would be inadmissible but not the evidence the confessions led them to. "I don't think there is any evil effect from the fluid or that it is harmful to the patient," prosecutor James Davis told the *News* on February 10, 1924.

"Persistent reports at police headquarters that Lou Glider and Ernest Harris, negroes, accused of the murder of Mrs. Juliet Vigilant [*sic*] and Mrs.

Elizabeth Romeo, had confessed under questioning last night were denied by the negroes," the *Post* reported on February 18, 1924. "Officers, however, declared, that the negroes being questioned separately under the drug confessed to the murders and told stories that corresponded exactly."

"Liberator of the Underworld's Darkest Secrets"

On February 26, 1924, B.V. Sturdivant, manager of the Southern bureau of the International News Service in Atlanta, wrote yet another article about the Birmingham cases as part of a series on truth serums that would appear in papers across the country. Prosecutor Davis told Sturdivant "scores of requests have come from police throughout the country asking information about the drug and its application to persons suspected of crime. Some requests have come from cities in adjoining states that we go there and put prisoners to the truth serum test."

Sturdivant described the many druggings he witnessed while researching the articles, but it does not appear he witnessed its use in Birmingham. "The subject falls into a heavy sleep. To any question he will answer the truth, it is claimed, because the drug has killed his will, temporarily, and deprived him of the power to lie. It is an all-powerful enemy of locked tongues and a liberator of the underworld's darkest secrets. It has great possibilities."

Sturdivant went on to describe how the drug "shatters the will power and paralyzes the conscious mind. This leaves the subconscious mind without a master. The truth is in there in the subconscious mind."

Dr. A.A. Goldberg, he reported, administered the drug to fourteen people in Birmingham under the watch of Davis. "When questions are asked there is but one thing to do—answer them. There is no will power to withhold it and no conscious mind to manufacture a falsehood."

"When the first drowsiness comes over him, they are told to remember a number. If they can remember it, the drug has not taken hold yet. Once it does, no third degree: No pushing and rough handling, no slaps or kicks or curses, no terrifying stage effects, no depriving of food or drink or sleep." They also kept the questions simple: "What is your name? Where do you live? How old are you?"

It had proven very effective in Birmingham, Sturdivant wrote. While Birmingham prosecutors predicted the drug would become as commonly

used a tool of law enforcement as fingerprints, Sturdivant acknowledged the very real limitations and dangers posed by its use. "In thirteen of fourteen of these examinations these questions have been answered—correctly, subsequent checkups showed."

"The dose must vary with each patient. In some instances one 'shot' is enough; in others four are required."

"When criminals adopt an attitude of silence in the Jefferson County Jail their tongues will be unlocked with this serum," Davis said. "It will become a generally used means of solving crime in a few years."

Goldberg emphasized that only experienced physicians should administer the drug because of the potential for "disastrous after-effects"—including death.

> There is too much chance of bungling unless the treatment is restricted to accredited physicians. It is perfectly natural that authorities all over the country are curious to try the drug. But it is dangerous stuff to fool with unless you know what you are doing. It may seem simple enough for the layman to inject the scopolamine-morphine into the arm, but one unfamiliar with it or unskilled has no way of determining when the patient has had enough.

Sturdivant, although not present for the Birmingham interrogations, provided the most detailed account of the use of scopolamine in the cases, seemingly transcribing the notes of those who were there.

"The case of Peyton Johnson, negro, one of the suspects, is typical, in the opinion of Solicitor Davis," Sturdivant wrote on February 27, 1924. "The prisoners to whom the powerful drug was administered were under its influence for varying degrees of time, generally from half an hour to two hours. Practically all of them talked freely." Johnson "denied without reservation" any involvement but told a different story under the drug, the article stated:

Q: Did you tie him [a man named Turner, who had been attacked and his watch stolen] before or after you hit him?
A: After.
Q: What did you do with the axe you hit him with?
A: Threw it into the corner.
Q: What did you do with Turner's watch?
A: An Atlanta man got it. I turned it over to him.

Q: How much did he give you for it?
A: Five dollars.
Q: What name?
A: Mumbles something like Vasser.
Q: How many times did you hit him?
A: I done told you that. I popped him every time. Once didn't do any good.

Another man, Odell Jackson, who was with Johnson at the time of the alleged attack, apparently corroborated Johnson's testimony. Under the influence of scopolamine, Jackson was quizzed in part as follows:

Q: How many times did Johnson hit the white man on the head?
A: He hit him—he knocked him down two or three times.
Q: Where was the money divided up?
A: At Johnson's house.
Q: Who got the watch?
A: Johnson got the watch.

Another man, Gilder, was questioned about the Romeo-Vigilante murders while under the drug's influence:

Q: You remember the night these two women were killed don't you?
A: I sure do.
Q: What did you do with those two watches?
A: Laid them down and got away. I heard the woman cry.
Q: Was it the young woman or the old woman who cried?
A: Must have been the young one.
Q: Who was it that hit the young woman, you or Buddy Harris?
A: I couldn't afford to call her back. It was a mighty bad lick.
Q: Where did you hit her, in the back of the head?
A: Yes sir.
Q: Who was it who hit the old woman, you or Buddy Harris?
A: Harris.
Q: What did you hit her with, the old woman?
A: It killed her.
Q: I know you killed her.
A: No, I didn't. What's the matter with you? [arouses for a moment]

"The quizzing of Gilder, as well as the other axe murder suspect, was done in a dark room, with a court stenographer taking testimony on everything that was said. The least light apparently affected the subject and tended to rouse him.…But all of them had the same reaction—they didn't know what they had said, the incriminating confessions they had given."

VERDICTS, VENGEANCE AND COPYCAT KILLERS

February–May 1924

s February 1924 drew to a close, three of the accused—Peyton "Foots" Johnson and Odell and Pearl Jackson—prepared to stand trial. Prosecutors said they would not use as evidence the truth serum that captivated reporters. "We have evidence worked up since the drug was administered that will convict the negroes," prosecutor Davis told the *News*. "No court in the world will enjoin me from obtaining evidence through the use of scopolamine, I don't believe. Methods used by the law, if not physically or mentally injurious in tracing crime, will not be ruled out in any court, it is my belief, and any lawyer who would give out a statement to the contrary, is just seeking notoriety."

With Peyton Johnson the first to stand trial, his defense used the family of the prosecution's star witness, Mary Sanders, to discredit her testimony. Sanders's sister, Baby Doll Hearn, said she and her sister left Birmingham for Beaumont, Texas, the Sunday before Christmas 1922, not returning until after the murder. A black man named Sam Noel testified he saw the sisters in New Orleans in January. "[Sanders] held up fairly well under severe cross examination from the defense and was released," the *News* countered. Hearn and Noel were arrested after testifying. "Evidence was produced by the state in the afternoon session showing that both witnesses had not told the truth."

According to Sanders, Peyton, Odell and Pearl went broke playing cards while drinking a liquor she called "skull and crossbones" in a downtown shanty with a group of about ten people early on in the night John Robert Turner was killed. The *News*, reporting on the testimony of February 28,

1924, stated for the first time that Lilly Bell, attacked with Turner at her home, died months later. In earlier accounts, she was said to have survived, however court records state she "went insane and died." Sanders said the three left with Ed "Bulls Eye" Jackson and a man identified only as Garfield. Sanders testified Odell said, "Let's go out and get some of those negro women and white men. Foots Johnson then said, 'Wait a minute.' He then went back to a trunk and took out some rope, which he put in his overcoat pocket."

Pearl, Sanders said, put on men's overalls, a man's hat and a man's coat. Then, she added, Odell went and got a pistol and they all left. Johnson, the Jacksons and the others, she said, came back around 1:00 a.m. "Odell divided the money and remarked, 'Well we got the white man but I don't think we got the woman.' Foots then said, 'Yeah, I know we got the man for I saw his brains.' Pearl said, 'We'll go skulling again if we can do this good.'" Sanders said the next morning she found a bloodied axe in an outhouse and asked Odell to get rid of it. Sanders testified that Odell, referring to either Ed Jackson or himself in third person, told her if she said anything about the axe, "Pretty Mr. Jackson will stamp your brains out."

State court records later gave this account: "Odell 'got broke' in the game, and in talking to the defendant said, 'Let's go out skulling and get these nigger women with these white men, * * * nigger whores with these white men'; and defendant said, 'All right.' Odell said, 'Wait a minute,' and he reached back in an old trunk, got this rope and put it in his pocket; and defendant said, 'Let's go up to big head Lilly Bell's house.'"

Sanders came to the attention of detectives, it was later revealed, when she and Pearl Jackson were serving time at the county farm for unknown charges, the *Post* would later report. Detectives Paul Cole and H.C. Propst heard the two women arguing when Sanders said: "You better look out. If you don't stop, I'll send you and your old man far away from here. Anything done in the dark is sure liable to come to light." They interviewed Sanders, and she finally confessed that the Jacksons murdered Turner.

Attorneys argued all day Friday, and the case was given to a jury at 4:00 p.m., the *News* reported. "Assistant Solicitor John McCoy in closing the argument for the state, made one of the greatest talks of his career as a prosecutor, spectators declare. For an hour and a half, he pleaded that the death penalty must be imposed":

> *We must begin somewhere to stamp out crime in Jefferson County. The*
> *evidence in this case shows beyond a shadow of a doubt that this negro*

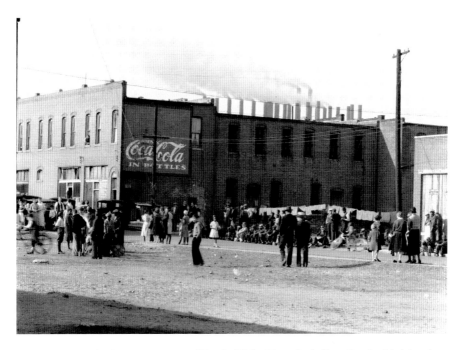

Birmingham steel mill workers, 1936. *Taken by Walker Evans for the Farm Security Administration.*

is guilty. Are you going to allow such a beast to be sent to the penitentiary among men, who although at the present time are state prisoners, will sooner or later return to society, where he can corrupt their minds and morals?

A verdict was returned at 8:00 p.m., after jurors spent ninety minutes at dinner. "It was stated that a ballot taken 10 minutes after beginning deliberation stood 11 for the death penalty and one for life imprisonment," the *News* reported. By the end, they were all in agreement—Johnson would die.

According to the *News*, Johnson displayed little emotion when he heard the verdict. He seemed unsurprised and said little, although he continued to protest his innocence. His alleged co-conspirator Pearl Jackson, on the other hand, reportedly broke out in tears.

"Foots would no more kill a man than I would," she wept, according to the *News* report. "They are going to hang Foots. Damn such a law!" George Frey, Peyton Johnson's attorney, said he would file an appeal. Johnson, who was in solitary confinement after his conviction, maintained his innocence and hoped he would be freed.

"TAKING NO CHANCES"

Ernest Romeo, brother of Juliet Vigilante and son of Elizabeth Romeo, was working on March 15, 1924, two weeks after Johnson's conviction, in the Southside grocery store where the women were slaughtered five months earlier. "Since that time, he has kept a revolver in his store," the *Post* reported. Romeo told police he saw John Harvey, a twenty-seven-year-old black man, stealing produce. Romeo chased Harvey from the store and shot him in the street, leaving him critically injured. Romeo, who was not arrested, "told police he had been troubled by the negro for some time," the *Post* added. "Romeo, police say, has been apprehensive of strange Negroes since then [the murders] and the shooting Saturday night showed that he had been under a heavy strain and was taking no chances," the *News* reported.

Clem Williams, a black coal miner who delivered the *News* in the Overton mining camp, was found with "his head split open" and an axe on his chest at his kitchen table, four days after the shooting, on March 19, 1924. Three men, all black, were arrested in Williams's death, but it is unclear if anyone was ever convicted. Was a copycat at work? "You may take an ax murder, for example, and play it up until some crazy person is driven to commit a similar murder," Sheriff Shirley told the *Age-Herald* months before the Williams murder.

On May 25, 1924, days before Pearl and Odell Jackson were to stand trial, two white men, L.M. Watkins and Richard Warner, were attacked with an axe as they walked through downtown on a Saturday night. "Watkins was the first one found, being discovered in front of a negro house at 1515 Fourth Avenue North, after the occupant of the house, a negro woman, had given the alarm. He had evidently been dragged about 20 feet and left in the front yard. He had been struck in the head with a blunt instrument, and all his pockets had been turned out. He was found by Detectives H.C. Propst and Paul Cole shortly after 11 o'clock Saturday night," the *Age-Herald* reported.

"Warner was found about 1:40 o'clock Sunday morning in front of a negro house at 800 Fourteenth Street, with an ugly wound on the back of his head and a gash over the eye. He was found by Detectives S.L. Williams and W.A. Dishroon, who stumbled over the body when they were about to enter the house of Bertha Davis, negress, to arrest a person for forfeiture of bond."

Two police officers on patrol at Eighteenth Street and Seventh Alley saw a black man walk toward them. "When they flashed their light on him they discovered he was carrying an axe," the report continued. "He threw the axe over the fence, the officers said, and attempted to run" but was quickly

stopped by the officers. One of the two went to retrieve the axe, while the other took the suspect to their patrol car. There, the man tried to take the officer's gun. In attempting to steal the officer's gun, he "locked the officer's wrist and nearly succeeded in wrenching his arm out of joint. Several shots were fired at the time, while both officers clubbed him over the head with the butts of the revolvers, until they believed he had been knocked unconscious," the *News* reported. The story continued:

> *Placing the negro in their automobile and recovering the blood-stained hand axe he had attempted to discard, they drove away to the city jail. They had hardly turned around, however, when the negro, who apparently purposefully feined* [sic] *unconsciousness to escape his captors, suddenly leaped out of the automobile and dashed away. The officers gave pursuit and fired fully a dozen shots at him until the negro finally staggered to his knees and fell sprawling at Fourteenth Street and Sixth Alley North.*

Police handcuffed the man and then rushed him to Hillman Hospital. It was later found he had been shot just once, in the right arm. After he was treated, the *Age-Herald* added, he "was carried to the city jail, where he refused to give his name, pleading the fact by innuendos that he was in a state of coma or insane." He was carrying "blood-stained coins and currency" totaling $14.36. The axe found by police had "splotches of blood on the blunt side, the blade, and the handle."

The only clue to the man's identity, according to the *News*, were the letters "F.O." sewn into his dark-green coat. As the victims remained in critical condition the day after the attack, police finally were able to identify their prisoner—he was Frank Owens, a man said to suffer from some unspecified mental illness. "Owens confessed to attacking one man, but laid the blame for the other on a negro who, he said, had accompanied him on the highway robbery expedition."

"Nothing could be gotten from the captured negro which would lead to the identity of his accomplice. Later the negro is said to have confessed knowing other negroes who have been indicted for participation in axe and alley murders in Birmingham during the last year. He will continue to be grilled, officials stated, in hopes of clearing points in some of the past murders." It was soon revealed, however, that Owens was not a member of the axe gang, he was merely inspired by them. Owens, the *News* reported, told police he was "determined to strike down pedestrians in the fashion pursued by the axemen."

"THE SKULLING PARTY"

While Owens sat in a jail cell two days after the assaults, Pearl Jackson stood trial before Judge Harrington P. Heflin and faced the possibility she and her husband, Odell, would soon receive the death penalty.

"She was placed on the witness stand in her own defenses and stoutly denied having had any part in the murder, adding that she did not remember anything that happened on the night the young man was found dead," the *Age-Herald* reported. "Mary Frances Sanders, star witness for the prosecution in the trial and conviction of Peyton Johnson, was placed on the stand on Tuesday morning and testified that she and the defendant had served terms on the county roads together for vagrancy and that she had threatened to expose her at the time. In the trial of Johnson, she testified that she had overheard Pearl and Odell Jackson describe the 'skulling party' that resulted in Turner's death." Tuesday night, just before 10:00 p.m., the jury convicted Pearl Jackson—she was sentenced to hang.

The nineteen-year-old now faced the possibility of being the first woman ever executed in Jefferson County, the first woman executed anywhere in the state since the Civil War and, with her husband, the first couple in Alabama history executed together.

The next day, Odell was tried while Owens made his first appearance in court in his own legal battle after being charged with assaulting two men. Owens again nearly died when he made a mad leap from a courthouse stairwell, perhaps to escape, perhaps to kill himself, as officers took him to be finger-printed. Owens "dived from the landing 20 feet to the pavement below. He struck head first and remained motionless for some time," the *News* reported. "He suffered no serious injury and refused to explain his act," the *Age-Herald* added. After he was examined, the hearing continued—briefly.

"They kept hitting me, judge, and wouldn't let me say what I wanted to say, so I just said 'yes' to every question they asked me," Frank Owens told Judge William E. Fort, according to the *Age-Herald*. "Owens spoke incoherently of being beaten and refused the right to make a statement when arrested Saturday night on charges of assault with an ax upon L.M Watkins and Richard Warner, both of whom are in a serious condition at a local hospital."

During Owens's trial, he "frantically waved his right arm which was injured by a bullet from one of the officers' guns and declared that it was 'alright,' that 'Christ had healed it,' and that 'nobody cares anything about

me but my wife and darling mother.'" Owens had a high fever during the hearing, the report stated. "Physicians stated he was not in fit physical condition to stand trial for his life."

His trial was postponed, the *News* reported. "The indictment was read to Owens and he was asked if he understood. The negro's response was hardly audible. His eyes held a half-wild and roving expression. Before leaving the courtroom, he managed to make it plain to Judge Fort he intended pleading not guilty." Solicitor James Davis expressed hope that the two victims would be well enough to testify by then.

Odell Jackson, meanwhile, stood trial for the Turner-Bell murders, with much of the testimony from Pearl's and Peyton Johnson's trials repeated. "The defendant seemed unperturbed," the *News* reported. "Aside from uttering a short exclamation on hearing the fate of Johnson and Pearl Jackson, he had evinced no signs of agitation, authorities say. He sits behind his attorney, Tom Roe, dressed in overalls, a white shirt, open at the neck, and chews gum incessantly. Occasionally he smiles at smart and sharp repartee with which the Sanders woman responds to the lawyers who are grilling her."

He, too, was convicted and sentenced to die. When the execution would happen was not clear because Peyton Johnson's conviction was being appealed to the state Supreme Court, and prosecutors wanted the three to die together, along with any other axe gang members they might arrest in the interim. Another previously convicted axe gang member, Fred Glover, had been sentenced to life in prison rather than death, but he was in the county courthouse the day of Odell's trial, facing charges he assaulted Sophie Zeidman in 1921 and robbed her of seven dollars.

"Glover told the jury he did not go near Mrs. Zideman's [*sic*] place on the night of the attack and knew nothing of it," the *Post* reported. However, Zeidman identified Glover as the man who assaulted her. He was again sentenced to life in prison. "In all probability, according to the latest plans in the sheriff's office, the three negroes will be hanged together," the *News* reported. "Assured now that a complete axe gang is in jail and convicted, authorities desire to make an example of them."

11

"THE PATHS OF SIN
TOO LONG I'VE TROD"

June 1925–September 1926

Time was running out for Pearl and Odell Jackson.

In January 1925, the Alabama Supreme Court ordered a new trial for Peyton Johnson, saying a letter stating Sanders was a "good girl" should not have been read in court. The justices upheld the death sentences, however, for the nineteen-year-old Pearl and her husband. Authorities planned to hang them one after the other, a first in Alabama, on June 19. Pearl Jackson told reporters she was confident she would be freed. "O'Dell Jackson has little to say," the *News* reported. The state board of pardons rejected their request for clemency, and their only hope of living was Governor William Brandon.

"Pearl has ordered for her final meal a whole chicken, a whole watermelon, a quart of ice cream and some tomatoes. She declared she felt fine and was unusually happy Thursday. She said she loved her husband better than any man in the world," the *News* reported the day before the scheduled execution. She was "ready to die as soon as she gets plenty to eat, she declared Thursday."

"Odell declared Thursday he did not know whether he was going to hang 'till it comes on.' He also was in fine spirits and said he felt fine and had plenty of sleep. Both still claim they are innocent of the crime for which they have been sentenced to die." Pearl wrote to the governor an "illiterate, but touching, letter," asking for mercy, the *Age-Herald* reported. "You know, governor, it's going hard with me unless you do something," the letter was quoted as saying. "Odell Jackson shows visibly the strain he is undergoing.

The front page of the *Birmingham Post* on June 18, 1925, told of the looming execution of Pearl and Odell Jackson. *From the* Birmingham Post.

He has taken to constant reading of the Bible, eating little and spends the nights in broken slumber."

While the couple held out hope Governor Brandon would spare them, county officials prepared to carry out the executions, the *Post* reported. "The scaffold had been oiled; the ropes stretched....The two negroes, occupying death cells that face each other across a narrow corridor, were today awaiting the end, studying their Bibles and hoping again for some last minute action by the governor that would save them." Odell was to hang at 10:00 a.m. "When his body is cut down, a few minutes later, Pearl Jackson will ascend the steel steps and stand on the same trap—and join him on the long road that was predicted for them more than a year ago."

The Jacksons had become "emotionally religious," the report stated. "Altho [*sic*] their cells face each other, they seldom speak. Odell was busily reading the Bible, slowly studying out the words....Pearl was in her cell, visibly serious but otherwise in good condition." Pearl said her last request was that a woman called "Spot Light" be allowed to stay in her cell that night. Edna Naro, a black woman serving twenty years for murder, was going to walk with Pearl onto the scaffolding. "Pearl will go to the gallows dressed in the height of fashion. She ordered a gray satin dress, white shoes, white silk stockings and white gloves for her burial attire....She wanted a hat, but the warden told her that she could not wear a hat and be hanged, as it would interfere with the rope."

As the Jacksons prepared for death, Brandon called to his office assistant solicitor John McCoy, the prosecutor who argued for the death penalty, to discuss the upcoming second trial of Peyton Johnson. Defense attorneys said new evidence at Johnson's trial—it is unclear what the evidence was—would clear him and the couple.

The governor delayed the execution until July 17. "Brandon indicated the three negroes were convicted on the same evidence and they should stand

or fall together," the *Post* reported. The governor telegraphed Chief Deputy Henry Hill, and he went to Pearl's death cell, where she had nearly finished her final meal. "She had eaten fried chicken, iced tea, bread, ice cream, cake, candy and was just preparing to finish off with a watermelon when Deputy Hill broke the news to her."

"Now I can have another meal just like this," she said. Hill jokingly told her: "We'll just have to take the watermelon back because you aren't going to hang tomorrow." Pearl, thinking he was serious, "demurred strongly," the report stated. "Odell Jackson had little to say beyond thanking the governor and protesting his innocence."

Peyton Johnson's second trial began and abruptly ended on July 6 when he suffered a "stroke of paralysis and toppled from his chair" in court, the *Age-Herald* reported. "An hour after Johnson was carried from the courtroom, he lapsed into a coma and was semi-conscious the remainder of the night. His condition was critical." The county physician declared he was not fit to stand trial. His trial and that of accomplice Edward "Bulls Eye" Jackson were postponed indefinitely. It was never clear if Bulls Eye was related to Odell or Pearl or what role he allegedly played in the crimes. Johnson, the day after collapsing, awoke in his cell but "was unable to rise from the cell cot and talks incoherently."

Pearl and Odell Jackson's date with death was once again delayed as Brandon scheduled their execution for August 7, in the hopes Johnson would recover and stand trial and perhaps the three, along with Bulls Eye, could hang together. It was the couple's third execution date in forty-nine days. Peyton Johnson, evidently recovered, and Bulls Eye Jackson stood trial on July 27; both were quickly convicted. After the jury deliberated for twenty minutes, Jackson was given life in prison and Johnson ten years—leased to the coal mines. "In the county jail, Pearl and Odell Jackson took on renewed hope, believing they will not be hanged because of the lighter sentences given the other negroes," the *Post* reported.

"Less than two months ago, Governor W.W. Brandon indicated that there was a doubt in his mind as to the guilt of the two condemned negroes, Odell Jackson and his wife, Pearl, when he granted them their initial stay of execution," the *Age-Herald* reported.

Brandon, on August 5, 1925, less than two days before they were to die, decided he could not allow the couple to hang for the murders when juries had allowed their partners to live. "I am unable to reconcile the verdicts of the four juries," Brandon said. "I believe that justice demands equal punishment, as nearly as possible, be meted out to all." Their sentences were

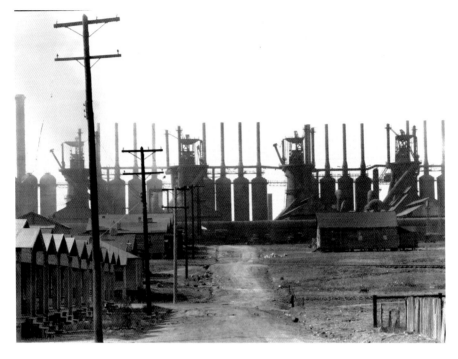

This 1936 Farm Security Administration photograph by Walker Evans shows Birmingham steel mills. *Library of Congress.*

commuted to life in prison. Repeated efforts over the years by this author to discover what ultimately happened to the imprisoned axe gang all failed.

"The commutation of sentence granted Odell and Pearl Jackson is believed to be the final chapter in the ax-murders which two years ago terrorized the Birmingham district," the *News* reported on August 8, 1925. While the *News* believed the story of the axe syndicate was over, Frank Owens would spend the next thirteen months in the county jail, fighting for his life after a jury sentenced him to hang for the copycat axe attack on two white men.

"Good-Bye, Frank"

"More than 100 negro men and women—prisoners of the county jail—were fasting and praying Monday that Frank Owens, negro, condemned to die on the gallows Friday for robbery, be spared from the extreme penalty," the *News* reported on September 20, 1926, more than a year after the

governor commuted the sentences of Pearl and Odell Jackson. In four days, Owens would face his death at the end of the very same rope the Jacksons barely escaped.

The parole board denied Owens's request for clemency after his victims showed members their ghastly axe scars, although a doctor called to testify by his defense attorney declared Owens was mentally ill. Sheriff Thomas Shirley, said to be a member of a powerful band of the Ku Klux Klan, was now lobbying Brandon to save the man from dying by Shirley's own hand.

Despite his Klan allegiance, Shirley was a well-known opponent of the hangings that he was required by law to carry out; he kept with him a small book holding the pictures of the four African American men he sent to their deaths by pulling the gallows' handle. "Plain Bill" Brandon, the son of a Methodist minister and well known for his reluctance to allow executions, had nonetheless taken no action as seventeen men were hanged in Alabama in his four years in office, according to records kept by the Death Penalty Information Center.

With Brandon unmoved by the calls for mercy—for reasons never disclosed—it appeared Owens was to be the eighteenth and last man he allowed to die, the fifth and final face added to Shirley's book and possibly the last man legally hanged in Alabama. In 1927, the state began using the electric chair, affectionately referred to as "Big Yellow Mama" because of its highway stripe paint job. Owens would also be one of the few executed in Alabama through the centuries for a crime less heinous than murder.

"Throughout the entire morning inmates of the negro section grouped around Owens' cell and participated in the prayer service which Owens conducted. The condemned negro has held daily prayer services from his cell each day for more than a month." The prisoners signed a letter to the warden saying they would forgo their meals "to give their spiritual aid and consolation to the condemned man."

"I have not given up hope yet. I do not believe I will have to hang. I don't want to die, and I have been praying to God to touch the heart of Gov. Brandon," Owens told the *Post* two days before he was to be executed. Owens, the *News* reported the day before he was to hang, had been reading the Bible, cover to cover, for months. "Seen in the condemned cell Thursday Owens was reading a chapter of the Book of Isiah [*sic*]."

As the week slipped away, Owens inched closer to becoming the first and only person associated with the axe murders in any way to be executed. "The rope which will be used was purchased and later stretched to hang Pearl and Odell Jackson and other members of the ax gang whose sentences

of death were later commuted to prison terms," the *Post* report continued. Each day brought him closer to becoming the fifty-second and final man to hang on the steel gallows used by Jefferson County for thirty-four years. With the advent of the electric chair, executions would move from the gallows of the county jail yard to the death chamber of Kilby State Prison.

"All plans for the hanging have been completed. The gallows has been greased, the rope stretched, and soapstoned, and the big knot has been tied," the *Post* reported the day before the execution. "Wednesday the governor told Sheriff T.J. Shirley that he would not interfere, and the sheriff returned here Wednesday night for his grim duty as executioner." Owens spent Thursday praying with his family and visited one last time with his wife. "If I have to go tomorrow, I will go with a clean heart. I have made peace with God."

"I'm not going to eat any more—except some fruit my mother sent me," Owens told the *Age-Herald*. "Owens greatest concern at that time seemed to be for his family—particularly for his aged mother." A pastor assured Owens they would be looked after and that his mother "was to enter his sanatorium the following day, Saturday, to remain for the rest of her life, if she saw fit."

During the hour of prayer and singing Thursday morning, Frank was the most composed member of the group. His voice could be heard above the others, who crowded around the steel door of his death cell. He led the group in a prayer and begged the Lord to make his people strong, to bear the burden. Frank's prayer was followed by another, and another, until finally every member of the group had prayed for mercy.

Some of the guards were seen wiping tears from their eyes as the hour of execution neared for the man many of them had come to know well over the course of his two-year-long incarceration. "Frank has been trying to escape the noose for a year and a half, and all the money his relatives could scrape together has been spent in his behalf." The *News* asked Owens the day before his execution: "Frank, you don't have to answer this unless you like, but are you guilty or not?"

"No, I ain't. But even if I was, I don't think I ought to be hung for robbery."

The sheriff bought Owens a blue mohair suit and accessories totaling $24.28 to wear on his dying day, an Alabama execution custom at the time. That cost included the 45 cents worth of black satin used to make the hood placed over his head just before the noose. "In the lapel of his coat was a negro lodge pin, while beside it rested a white rosebud given to him in the death cell by Deputy Warren Cochran. Two white carnations protruded

from his coat pocket. An hour before the execution, ministers and friends of Owens gathered at his cell for services. Several songs were sung, and Owens made a long talk. Following the service, Owens shook hands with both the whites and negroes around his cell. One of the men he asked to tell him goodbye was Solicitor Jim Davis, who led the fight to break Owens's neck. Davis shook hands and said slowly, 'Good-bye, Frank,'" the *Post* reported. As Owens said his final goodbyes, 500 people filled the jail yard to watch the hanging and another 1,500 waited outside when they couldn't get in, hoping to see his body carried off to the ambulance, the *Post* reported. Traffic in the area was blocked. Women peered out of nearby office windows and reportedly smiled and laughed as the grim scene unfolded.

Two black ministers, the Reverends Jim Pearson and George Staffney, joined Owens at the scaffold. "I want to thank all the good white people for all they've done to save me," Owens said. "I don't feel I've had a square deal, but that's with the Lord." Owens dropped to his knees and prayed: "Catch my soul, oh Lord, God! Search my heart and if there is anything bad there, take it out, Jesus." Owens, the *News* reported, also "asked God to bless the officials of the county, and bestow additional blessings on Sheriff Shirley."

"His prayer became a chant. Although he had remained collected to this point, his chanting" continued until the hood was placed on his head. "A minute later Shirley sent Owens to his death."

"The trap was sprung as negroes in the courtyard sang 'I've Wandered Far Away from God—Now I'm Coming Home.'" The people sang: "The paths of sin too long I've trod. I've wasted many precious years, now I'm coming home."

"The negro died bravely. As the noose and black cap were being adjusted he stood firm and composed. He told Deputy J.H. Sprinkle when it felt like it was adjusted on the proper spot on his neck so it would bring instant death." The gallows were sprung at 11:12 a.m., the *News* reported. "The big knot on the hempen rope broke Owens' neck and he was pronounced dead 15 minutes later."

"I could not be any happier if I were in Heaven," Warner told the *Post* during Owens's execution. "It is not that negro's fault we are alive," Warner said. "I am glad that Watkins and I have lived to see Owens pay for his crimes." Watkins told the crowd he was not fully recovered and suffered partial blindness in one eye and "a deep dent" in his skull. "Prisoners in the county jail watched the hanging with the aid of hand mirrors. The mirror was poked thru the window at an angle so that a reflection of the gallows could be seen."

"The Perpetrator of the Tragic Deed"

As the Saturday, September 25, 1926 edition of the *Age-Herald* carried news of Owens's execution the day before, a short item was tucked away inside the paper under the headline: "$200 OFFERED FOR SLAYER OF ALPER."

Governor Brandon, who just allowed Owens to die, was offering a reward of $200 after a haberdasher, either age sixty-four or seventy-four, depending on which press account you prefer, was struck down with a foot-long piece of iron pipe in his shop four days before the execution. Benjamin A. Alper died two days later at South Highlands infirmary, two days before Owens lost his life.

On the final Monday morning Owens led jail fellow inmates in song and prayer, seventeen-year-old Joseph Alper went to join his father, a Jewish émigré from Russia, at the family's hat shop at 302 Eighteenth Street North. His father had left home two hours earlier, around 7:30 a.m., with $700 in cash from Saturday's sales. Joseph, surprised to find the door locked, peered through a window and saw a body lying in a pool of blood. He frantically went to borrow a ladder, shimmied through the transom and called an ambulance for his father, who was on the edge of death. A motorcycle officer, hearing the sirens, broke down the door.

"Police are bending every effort toward finding the perpetrator of the tragic deed which they declare is as brutal as the crime for which Frank Owens, negro axe man, is to hang Friday," the *Age-Herald* reported on September 21, 1926. Detectives H.E. Morris and Thomas Christian said they believed a "customer" followed Alper into the shop, saying he wanted a cap, and when Alper went to get it, struck him from behind. "He continued to beat him with an iron wrench handle until he believed his victim was dead....Detectives found the wrench handle and a brand-new cap, apparently dropped by the man when he was struck, laying on the floor."

His "head beaten to a pulp" from repeated blows, as the *Age-Herald* reported on September 23, 1926, Alper's pockets and cash register were emptied before the killer locked the door and fled. "At the hospital he revived sufficiently to tell police that a negro did the act, but whether he entered as a customer or sneaked in could not be learned," the *News* reported on September 22, 1926.

"All efforts to locate the bandit have failed but Detectives Morris and Christian are working on the case and hope to make an early arrest,"

the *Post* reported on September 23, 1926. "Wednesday night, detectives assigned to the case had been unable to throw any light on the murder," the *Age-Herald* added.

No mention was made in any of those articles of the many terrible murders stretching back nearly seven years, although the brutal axe attacks clearly matched the method of Alper's murder. No mention was made of the terror that gripped Birmingham mere months before, the truth serums or the hasty trials.

This Magic City, which started the century with the promise of prosperity rarely seen anywhere in American history, now lurched toward the Great Depression, World War II and the bloody specters of violence and segregation that haunt Birmingham still today. With each new year and each new murder, the tragic legacy of the city's "ax-wielding fiends" was washed from our collective memory like a puddle of blood mopped from a grocery store floor.

BIBLIOGRAPHY

Brownell, Blaine A. *The Urban Ethos in the South, 1920–1930*. Baton Rouge: Louisiana State University Press, 1975.

Connerly, Charles E. *"The Most Segregated City in America": City Planning and Civil Rights in Birmingham, 1920–1980*. Charlottesville: University of Virginia Press, 2013.

Davies, Sharon L. *Rising Road: A True Tale of Love, Race, and Religion in America*. New York: Oxford University Press, 2010.

Fede, Frank Joseph. *Italians in the Deep South: Their Impact on Birmingham and the American Heritage*. Montgomery, AL: River City Publishing, 2001.

Newton, Michael. *Ku Klux Terror: Birmingham, Alabama, from 1866–Present*. Atglen, PA: Schiffer Publishing, 2013.

Norrell, Jeff. *The Italians from Bisacquino to Birmingham*. Birmingham, AL: Birmingfind, n.d.

Sterne, Ellin. "Prostitution in Birmingham, Alabama, 1890–1925." PhD diss., Samford University, 1977.

Suitts, Steve. *Hugo Black of Alabama: How His Roots and Early Career Shaped the Great Champion of the Constitution*. Montgomery, AL: NewSouth Books, 2005.

INDEX

ABOUT THE AUTHOR

Photo by Frank Couch.

Jeremy Gray has covered the news in Alabama since 1999. After years of chasing police through the Magic City as night reporter for the *Birmingham News*, he is currently a managing producer for Alabama Media Group, helping share breaking news on AL.com and in the pages of the *Birmingham News*, the *Huntsville Times* and Mobile's *Press-Register*. A Bessemer, Alabama native and father of two, Gray is a graduate of McAdory High School and the University of Montevallo and lives in Moody, Alabama.

Visit us at
www.historypress.net